ARI

G O U A C H E

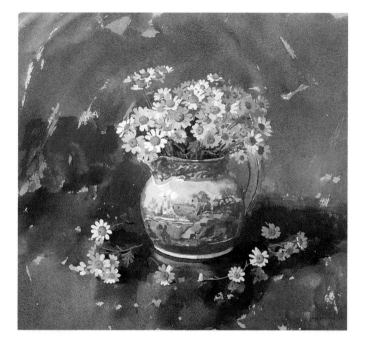

a personal view

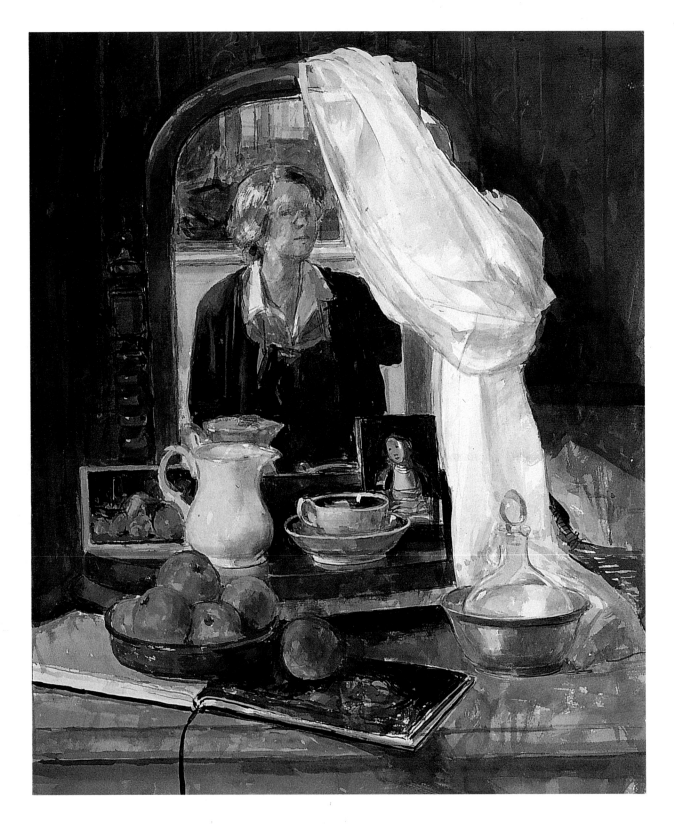

SELF-PORTRAIT WITH DISH OF RUSSET APPLES
Gouache, 22x18in (56x46cm)

PAMELA KAY

a personal view

GOUACHE

David & Charles

*This book is dedicated with grateful thanks to my husband,
Tony Bryan, and my daughters, Victoria and Hannah*

ACKNOWLEDGEMENTS

It has been a family affair. Without my husband's tireless efforts at
his word processor this book would never have been written. He
made sense of my syntax and corrected the spelling, constantly
encouraging and advising me. In addition he took all the
photographs. I would like to thank my daughters Victoria and
Hannah Bryan, and my mother, for reading the early drafts.
My grateful thanks must also go to John Ward in whose atelier I
learned so much. Finally, for her forbearance and calm direction,
my editor Alison Elks.

A DAVID & CHARLES BOOK

Copyright © Text & Illustrations Pamela Kay 1995
Copyright © Photographs Tony Bryan ARPS
First published 1995

Pamela Kay has asserted her right to be identified as author of this work in accordance
with the Copyright, Designs and Patents Act 1988.

A catalogue record for this book is available from the British Library.

ISBN 0 7153 0289 2

Designed by The Bridgewater Book Company Limited

and printed in Singapore by C. S. Graphics Pte Ltd
for David & Charles

Page 1 FEVERFEW IN A BLUE SPODE JUG
Gouache, 9¹/₂x12in (24x30.5cm)

Page 5 ROSE 'MME ALFRED CARRIÈRE' IN A GLASS
Gouache, 11x8in (28x20.5cm)

CONTENTS

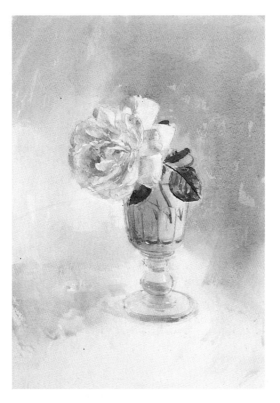

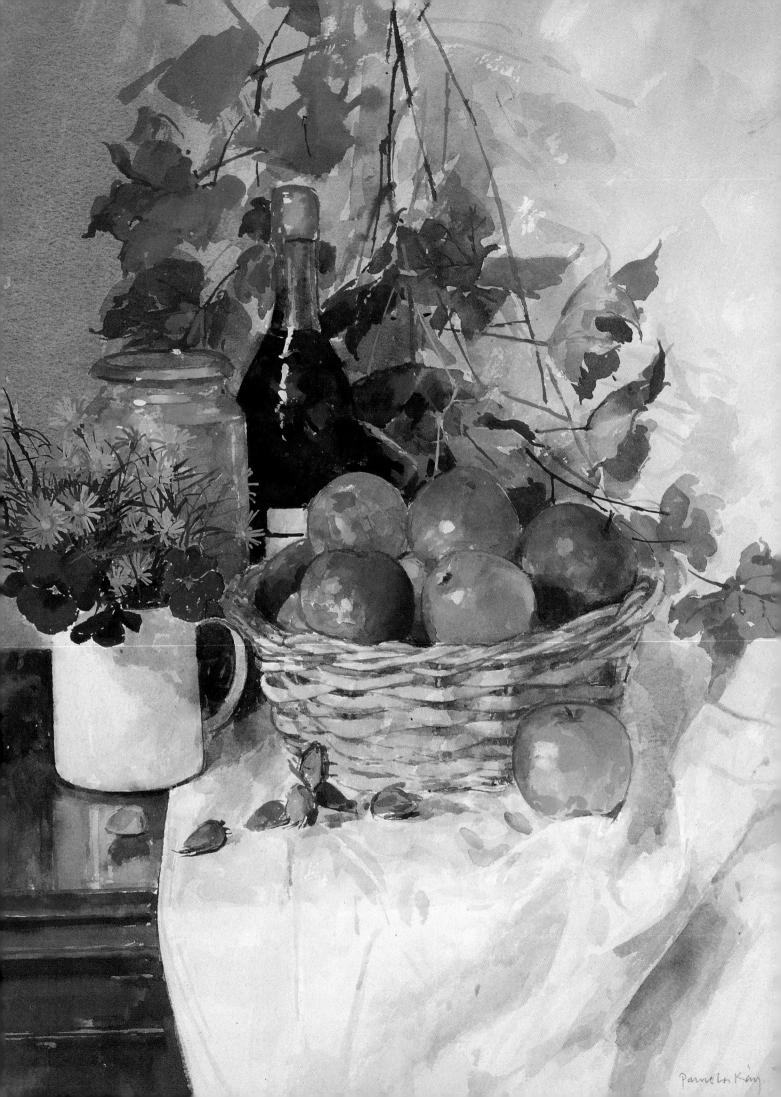

Pamela Kay

INTRODUCTION

Whenever I have the opportunity of talking to interested visitors and fellow painters at exhibitions of my work, the discussion invariably turns to my watercolours and how they were painted.

I explain that they are watercolours and they are painted in gouache. This explanation, although truthful, is usually received with a look of stunned pain, rather like a severe blow between the eyes would produce. The confusion is tangible: 'What is gouache? I thought these paintings were done in watercolour'.

I point out that watercolours and gouache are one and the same thing, but slightly different, and so, quite unintentionally, tend to confuse people even more.

Many believe that, at least, I must have begun the paintings with watercolour pigments and then 'finished them off' in gouache; that is, if the two media mix at all. Many are surprised that I have used gouache because the paintings look like 'watercolours'. Where does one end and the other begin?

Opposite
COX'S ORANGE PIPPINS IN
A BASKET WITH VINE LEAVES
Gouache, 18x22in
(46x56cm)

THE MONET CUP AND SAUCER
AND SUMMER FLOWERS
Gouache, 9x11in (23x28cm)

LATE SUMMER FLOWERS IN A
GREEN GLASS
Gouache, 11x8¹/₂in (28x21.5cm)

*There is hardly any paint on this very delicate white pansy. It was
painted first using very pale cool greys and left severely alone – the
rest built up gradually all round it.*

*Its surroundings are quite rich in colour and low in tone to
emphasize the pansy's fragility and high key.*

Opposite
BASKET OF PANSIES
Gouache, 13x18in (33x46cm)

*There is an unfailing delight in filling baskets with anything.
They always look inviting.*

*This beautiful wooden chip basket, of a type that was in
constant use before the advent of universal cardboard, will contain
anything gracefully. Its shape is functional and architectural on a
small scale.*

*To cram it with pansies and sit it on translucent sheets of tissue
paper in front of glazed cupboard doors is a perfect painting
arrangement. All the flowers crane outwards inquisitively, each
one quite different from the others.*

*It is by observing closely their precise differences and not
attempting a lazy generalization that the painting has an edge.*

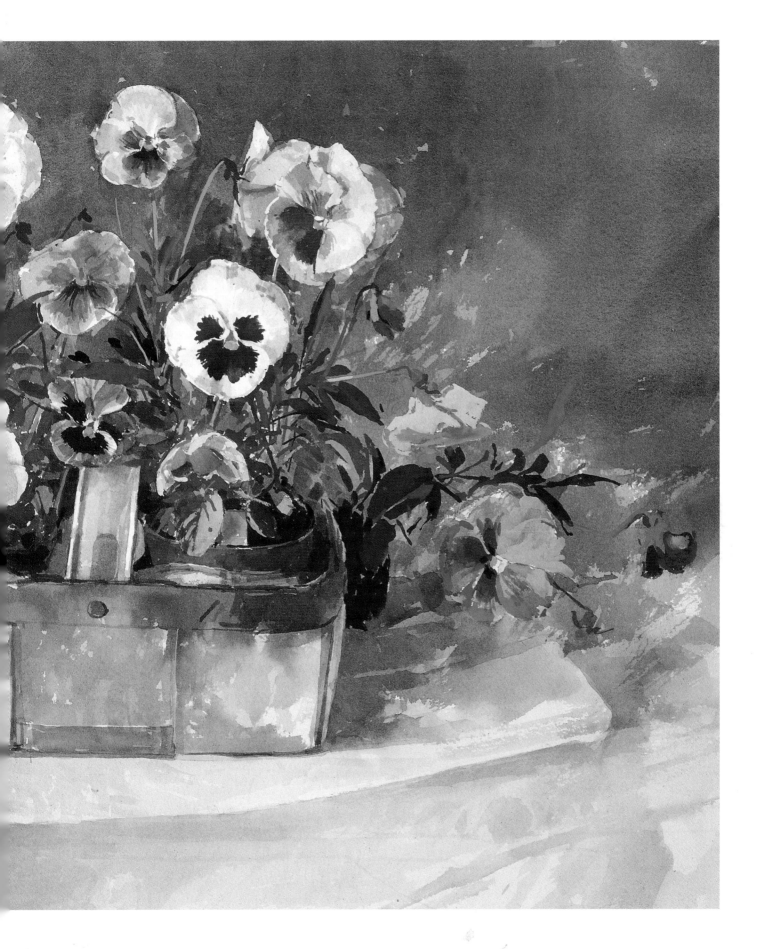

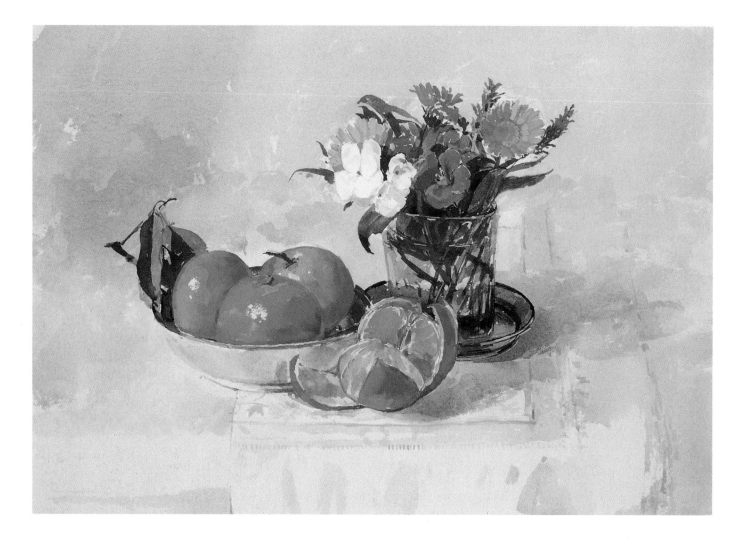

SAUCER OF CLEMENTINES AND FLOWERS
Gouache, 9x12in (23x30.5cm)

Yellow is a notoriously difficult colour to handle as it sullies instantly. It is easier if it is surrounded by a darker tone, but when the painting is light and delicate in handling, it is far more difficult to hold on to the yellow's purity and luminescence.

I have combined the techniques of pure watercolour in the transparent washes of gouache used in the saucer and white pansy heads. As the tones darken, it is possible to paint lower in key to achieve richness.

Opaque colours lift the form where it gets too dark, but allow a saturation of colour in a predominantly pale scheme without it all looking delicately washed out. It still has a force behind it.

10

It was suggested that I should write a book about it, and attempt an explanation at greater length. There have been enough 'how to paint' books written to sink a small off-shore island; this is not going to add to that number.

From the outset, I would like to emphasize that this is a very personal 'how *I* do it', not 'how *to* do it', book. No book can tell you how to paint. I think that it is wrong to say 'This is how you should paint'. Everyone has their own voice, their own handwriting, their own fingerprint on everything they do. Why then should they paint like someone else?

Someone once asked James Stewart how to become an actor. 'You act,' he said succinctly. It is the same with painting. You only learn about painting by doing it. Books can help you to learn to *see*, and this is of far greater value.

Finding the medium that feels right for the way you work is very important, and being at ease with the technical side of the work frees the mind to concentrate on painting itself. Over the years, I have found painting with gouache suits my way of working in every respect. Throughout the book I will explain the varied ways I use gouache, and how, in particular, the choice of this medium influences the way I work.

As a student at art school I studied 'fine art', a grand name for painting. Because our principal, John Moody, wisely assumed that no one could possibly make a decent living from their painting alone and needed the added skill of a 'craft' of some sort in order to earn a living, I also chose textile design as a subsidiary subject.

Designs for textiles were executed, in the main, using gouache paint. It is perfectly flat in its covering consistency on a design, and richer in colour yet finer than the more crude

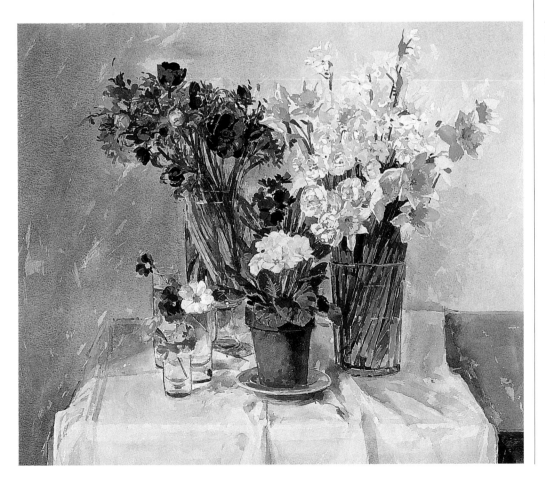

TABLE OF ANEMONES AND
SPRING FLOWERS
*Gouache, 18x22in
(46x56cm)*

BASKET OF WHITE PEACHES
*Gouache, 9¹/₂x13in
(24x33cm)*

medium of poster paint. It also comes in an enormous range of colours. From a very early stage in my training, I was used to handling gouache.

Tubes of 'pure' watercolour were kept exclusively for pale washes on working drawings, or for use with pen and wash sketches: rarely for making watercolour paintings. Tubes of neutral tint and sepia were constantly in short supply at the college shop because we all used them for life drawing – adding blobby tonal washes to drawings of lumpy bodies that used to end up looking very grey and metallic. As a medium, watercolour has never really been taught in art colleges; it just seemed to happen. Gouache, however, was a positive tool of the trade.

Early familiarity and constant use made gouache the obvious medium for me to use when I finally gave up my textile design practice in the mid 1970s and made the decision to go back to painting full time, rather than in moments snatched between designing colourways for curtains.

This book elaborates on the way I use the medium, and the things I love to paint. The medium is only a small part of the process. The emphasis laid upon style and materials

THE WINCHCOMBE BOWL
Gouache, 9x11in (23x28cm)

It is the simplest things that make the most satisfying paintings. Here a large, unblinking, ox-eye daisy in a fluid green glass sits comfortably behind the dish. This delicately glazed bowl came from the Winchcombe pottery in the Cotswolds, and is full of colour.

The group is held together in a geometrical framework as it sits on a white napkin in front of the glazed doors of a cupboard. All is calm serenity, in a gentle light.

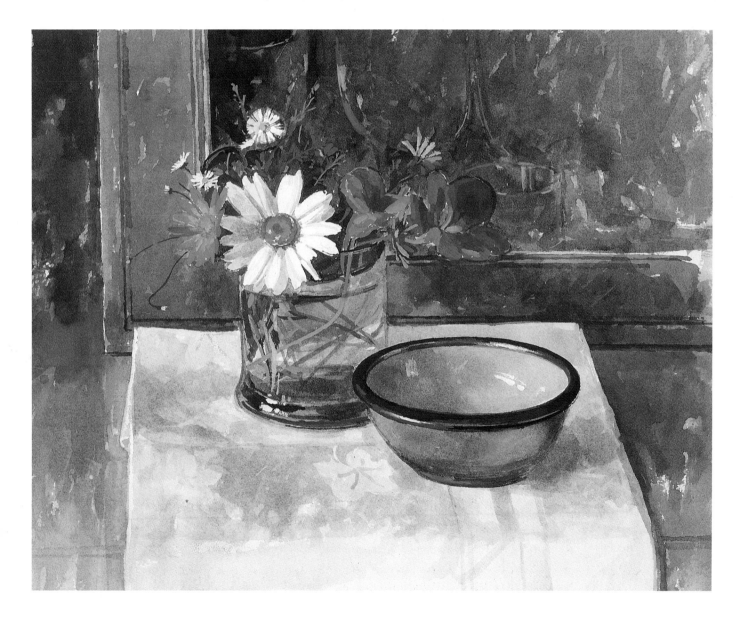

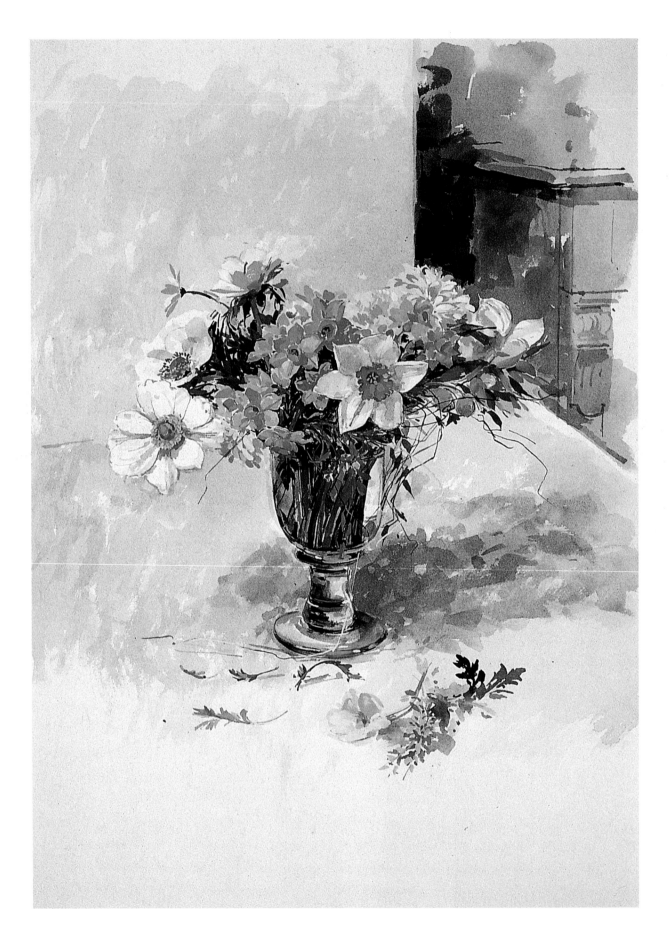

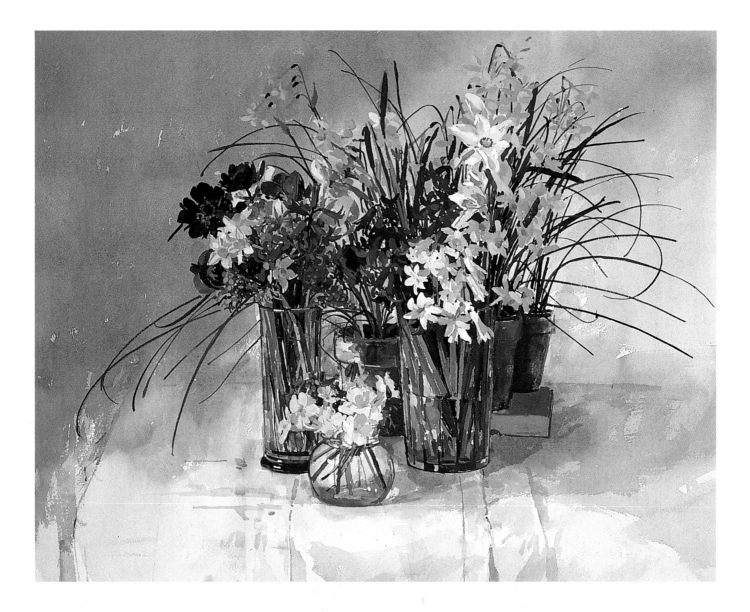

today is unbalanced, I feel. They are only the means to the end. The quality of life and the things which surround one are every bit as important to the work as the materials.

My husband, a fine but modest photographer, made himself quietly unpopular by winning all the prizes at his local photographic society exhibitions. On one memorable occasion, a fellow photographer sidled up to him and asked earnestly what camera he had that took such wonderful photographs. 'A Nikon,' my husband replied immediately, giving all the details down to the length of the neck strap. 'I would love to take photographs as good as yours,' he said, 'and I know I could, if only I had the same camera.'

Sadly, this naïve view is not confined to photographers. I can, and do, tell anyone who asks what media, paper and palette of colours I use, but I think how you see things is every bit as important, and you can't get a personal point of view in a shop. It is the eye of the beholder, not a No 6 Kolinsky Sable brush in the hand, that matters.

Chapter One

GOUACHE

I t may seem strange to begin a book about gouache with a description of water-
colour, but the confusion I am hoping to unravel demands a speedy definition of
terms, as both watercolour and gouache are water-based media that use water as a
thinning agent.

A painting normally referred to as a 'watercolour' is generally accepted to have been
painted on a sheet of good quality, specially made, tough paper and consists of stains of
transparent washes laid carefully one over another. These washes ultimately build up to a
saturation of clear but essentially luminous colour areas.

Pure watercolour can, of course, be handled in many different ways, but its main char-
acteristic is that of transparent washes of colour, however applied, that make full use of
the paper as the lightest tone.

The pigment itself comes in pans or small tubes. It is exceedingly finely ground and
mixed with small amounts of gum binders which are water-soluble and act as lubricants.
Watercolour paint is a much-loved medium that most painters are familiar with and know

THE GRAND CANAL
*Watercolour, 13x18in
(33x46cm)*

Opposite
SALUTE, EARLY MORNING,
VENICE
*Watercolour, 14x10in
(35.5x25.5cm)*

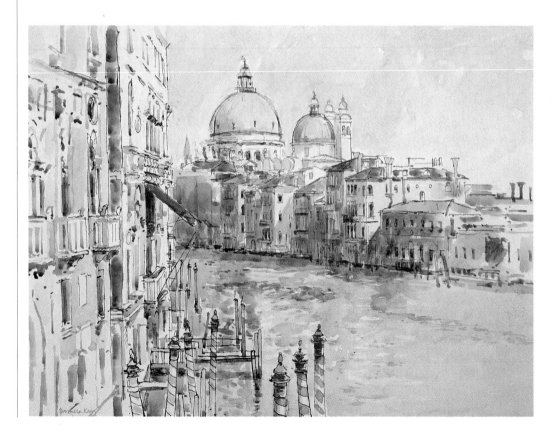

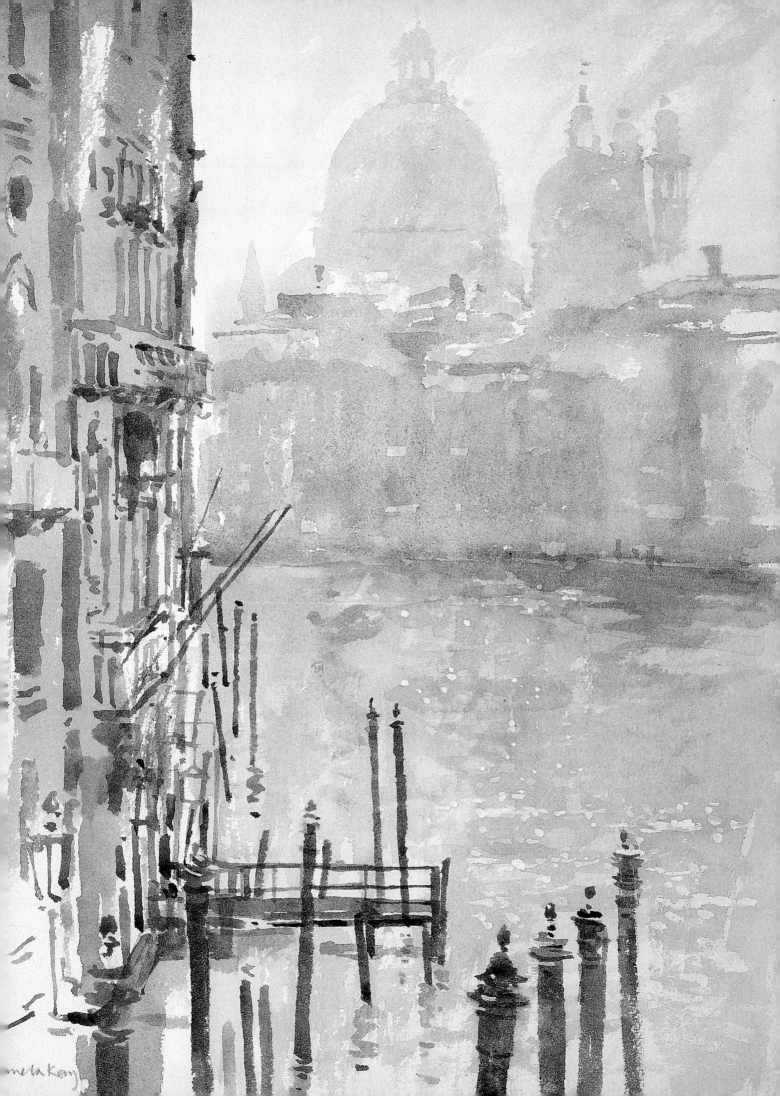

melakey.

VENICE FISH MARKET
Pencil

how to use. It is referred to most frequently as 'pure' watercolour, a term which acknowledges the difficulties in handling it and the many prohibitions that have accumulated around its use over the years.

It is interesting, I think, that the word 'watercolour' is rarely seen or heard without its qualifying friend 'pure'. It has a nun-like incorruptible air about it which many may find intimidating; a holier-than-thou medium, for the initiated only.

Unquestionably, then, pure watercolour is a thoroughbred medium with a thoroughbred's associated nervousness. It makes great demands on its handler and can fall at the slightest fence in uncertain or inexperienced hands.

Watercolour cannot be pushed around too much. A fast-moving, bravura medium, it is happier if it is right first go; if harried with a brush it can threaten to disintegrate into a quiet, muddy senility, tired and tatty round the edges. For this reason, I find watercolour is ideal for the rapid sketch; the fast-moving, spontaneous statement – an 'on-the-spot' observation.

A pen drawing that has as much information as is needed can be enriched with washes of colour to give it an added dimension. A fleeting effect of light needs a rapid shorthand, perhaps on a small scale. Watercolour is ideal.

When I work abroad, I use pure watercolour in pans, because it is so conveniently portable and compact. The painting of *Salute, Early Morning, Venice* (page 17) came

Opposite
VENICE FRUIT MARKET
Pencil

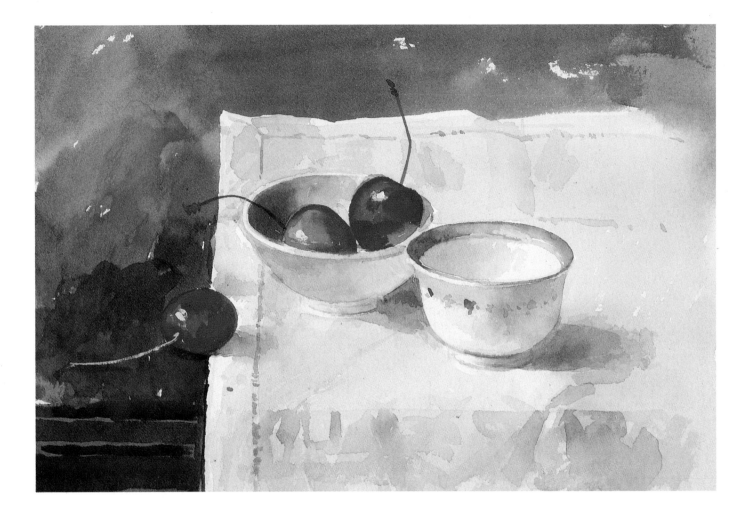

TWO BOWLS, THREE CHERRIES
*Watercolour, 6x8in
(15.5x20.5cm)*

about quite by chance. I had been working on a large landscape-format, pen and wash drawing of the same view, but in the afternoons, in bright sunlight.

I returned early the next morning merely to draw in more precise detail the buildings on the left-hand side of *The Grand Canal* (page 16). The light was no longer important as I had completed everything else. To my astonishment, the Salute was wreathed in a fine mist and so extraordinarily ethereal that I immediately began a new watercolour of it, and worked very quickly before the mist evaporated with the strengthening sun. I had about half an hour before it all changed. Watercolour was the perfect medium for the job.

Most such work done abroad – producing a quick travelling holiday watercolour, rather than the product of a more considered fortnight anchored to one place – is essentially evocative and speedy in nature. For me, pure watercolour is a lightweight, portable way to embellish drawings or make rapid notes. I would not normally use gouache for this purpose. Pure watercolour is such a kind medium, too. You can throw a deep stain of colour on an area and it will dry obligingly fainter in tone, giving you another opportunity to nudge it darker if you wish. It is useful to think of it as a 'stain' of colour, as this will help enormously when distinguishing between watercolour and gouache.

The small painting *Two Bowls, Three Cherries* (above) is entirely 'pure' watercolour. This was an unassuming group that had everything needed to make a simple yet satisfying painting. Executed in half the time you might think, it was happily right first go –

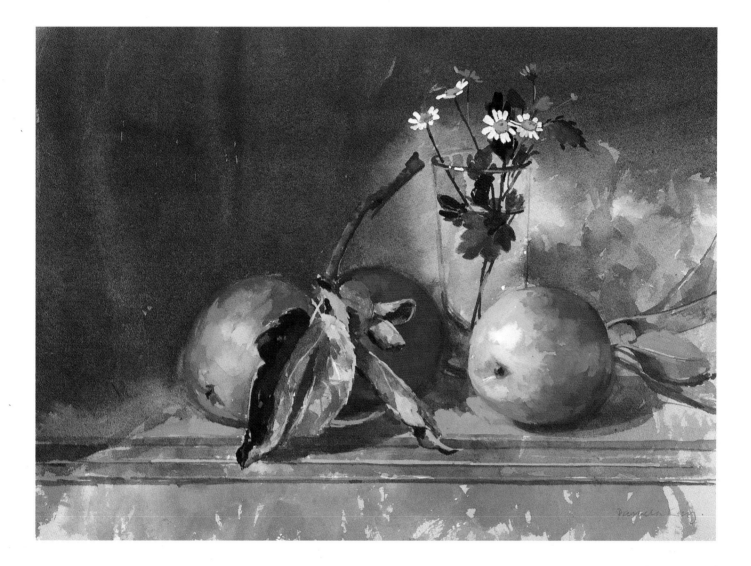

WORCESTER APPLES
Gouache, 9¹/₂ x 13¹/₂ in (24 x 34.5 cm)

*The depth of tone in the background of this small painting of
apples is a good example of how rich gouache can be. I have seen
similar handling in watercolour, but it takes enormous skill to do.
It is simple and direct in gouache. There are probably no more than
three or four layers of wash in this background.*

*The apples are placed on the shelf inside a cupboard that sits on a
dresser, so there is a very slight change of plane that adds interest
and finality to the composition. The glass of feverfew gives the
necessary vertical, but this time the underlying geometry is that of
a triangle, delineated by the twig and the edge of the cast shadow.*

*By far the most important part is the nearest leaf, drawn in
some detail, using pigment as transparent as possible in both the
lights and the darks. The final delineation of crisp edges is painted
in opaque colour with a fine brush.*

21

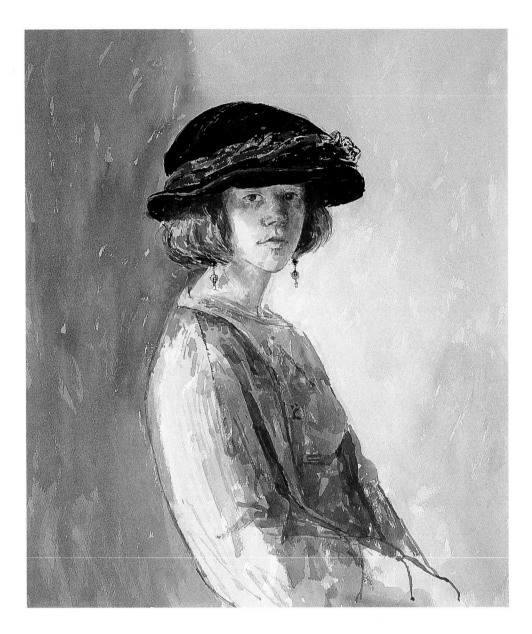

HANNAH DRESSED BY OXFAM
Gouache, 22x18in (56x46cm)

Compare this portrait of my daughter, which has been painted in gouache, with the rapid watercolour sketches of Petra and Venice (pages 16–17 and 25). The portrait has been painted in a 'watercolour' way, but has a far greater saturation of colour in the dark areas, and a greater solidity.

It has, of course, had more time spent on it. It is an example of how opaque 'body colour' has been used very sparingly to lighten areas that had become too dark – on the veiling on the brim of the hat and around the neck of her blouse.

There are a few lighter opaque touches in her hair and on the face – again as a rescue remedy.

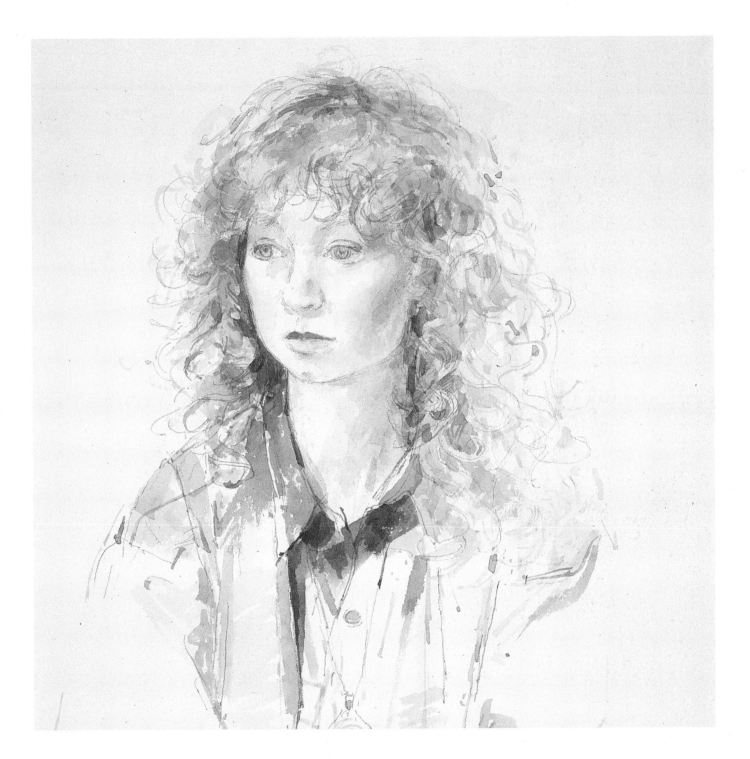

JULIA (detail)
Watercolour and pencil,
21 x 15 in (53.5 x 38 cm)

then left alone. The paper itself has been left untouched to describe the highest tones. This is an example of how, after a week's intensive painting on a large scale in gouache, a very small watercolour almost painted itself.

 The extraordinary quality of the colour as it settled good-naturedly on the surface of the paper gave enormous encouragement. I drew the inside and shadow side of the bowls directly with the brush in pale greys, the washes drying and offering the possibility of refinement, should it be necessary. The warm, translucent colour of the cherries spiced up the otherwise neutral colour scheme of browns and greys.

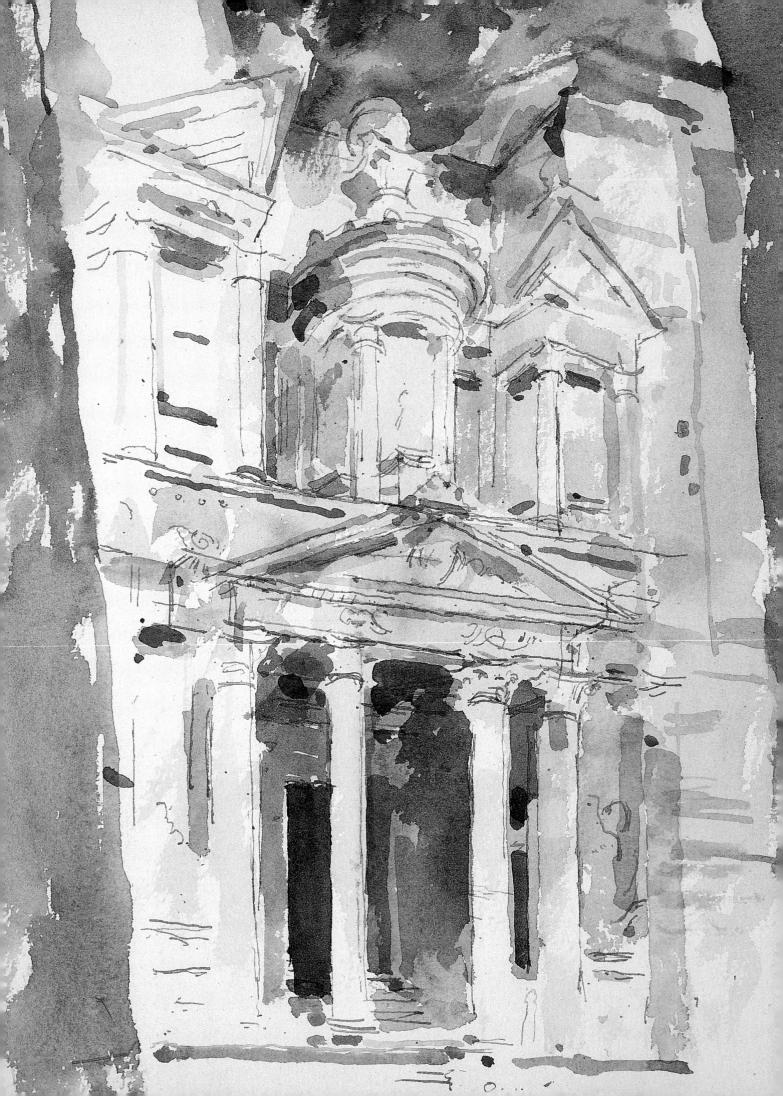

This happens rarely enough to be remarkable, and the freshness of the watercolour is at its most successful when this fortunate, and for the most part unforeseen, set of circumstances occurs.

In a more considered, even painstaking, way, watercolour can be used for studio paintings. Layer upon layer of transparent washes carefully put down, perhaps over pencil or pen drawing much as John Sell Cotman did, can result in larger paintings of a grander design than a finished 'sketch', but this takes much longer and is a very skilled business. I firmly believe, however, that there is a halfway house between the media of watercolour and oils, and it is gouache.

In many ways, gouache is a step further on towards the very distant direction of oil painting. If you enjoy painting in both oil and watercolour you will find it easier to translate to gouache. If, however, you only work in watercolour, it is possible that the transition to gouache could be much more difficult. Happy watercolourists enjoy the strictures and limitations of their craft, I find. Oil painters, and by the same token gouache users, are possibly more anarchic by comparison. It's a matter of temperament.

Gouache is a water-based medium also. It is a form of watercolour. It uses the same pigments, but differs from 'pure' watercolour in that the pigment is not as finely ground in the manufacturing process, and it is bulked out with white fillers, or body colour. There is a sturdier binder, and it comes in fat tubes rather than pans. It is coarser and more opaque than pure watercolour.

Its strengths are its opacity and brilliance of colour. It is much cheaper than watercolour, goes further and will suffer a much heavier hand. Nowhere near as fastidious as pure watercolour, nevertheless it requires handling with some care. As with any medium, practice is the only way to progress and to understand it better.

It is important to remember that watercolour can be used with gouache if you so desire. I happen to think that this is unnecessary, but they are perfectly compatible from the point of view of their chemical composition.

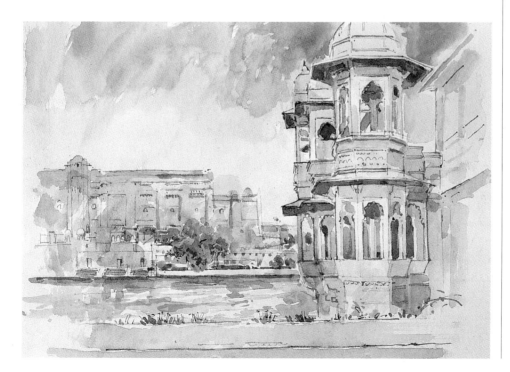

THE FORT, UDAIPUR,
FROM THE LAKE PALACE
*Pen and wash, 9¹/₂ x 14in
(24 x 35.5 cm)*

Opposite
THE TREASURY, PETRA
*Watercolour, 11¹/₂ x 9in
(29.5 x 23 cm)*

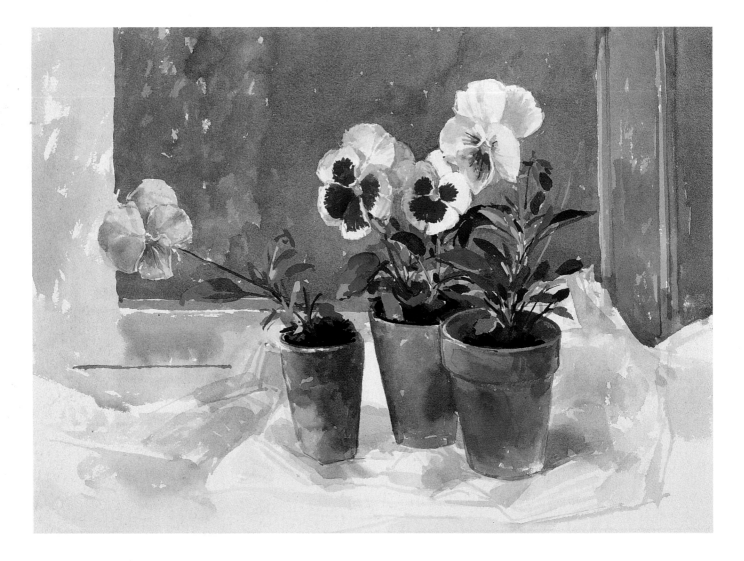

THREE POTS OF PANSIES
Gouache, 9x12in
(23x30.5cm)

Opposite
SUMMER FLOWERS IN A BLUE JUG ON A PEWTER PLATE (detail)
Gouache, 13x14¹/₂in (33x37cm)

*The dark ultramarine blue glass of the jug, sitting on a light
pewter plate, gives a dramatic tone to a delicate subject. It is a
simple right-angled composition, softened by the complex cascade
of rose petals.*

*Painting pewter is no more simple to analyse than painting any
other surface. It is primarily to do with observation. What is
there? What is the colour? Is it a warm grey or a cool umber? Does
it have any sienna in it, making it yellow in character? Is it light
or dark in tone? Is it a pale wash of jet black and blue, or a darker,
heavier tone echoing its immediate neighbouring colour? Is the
shadow under the plate warmer or cooler, bluer or yellower than
the colour next to it?*

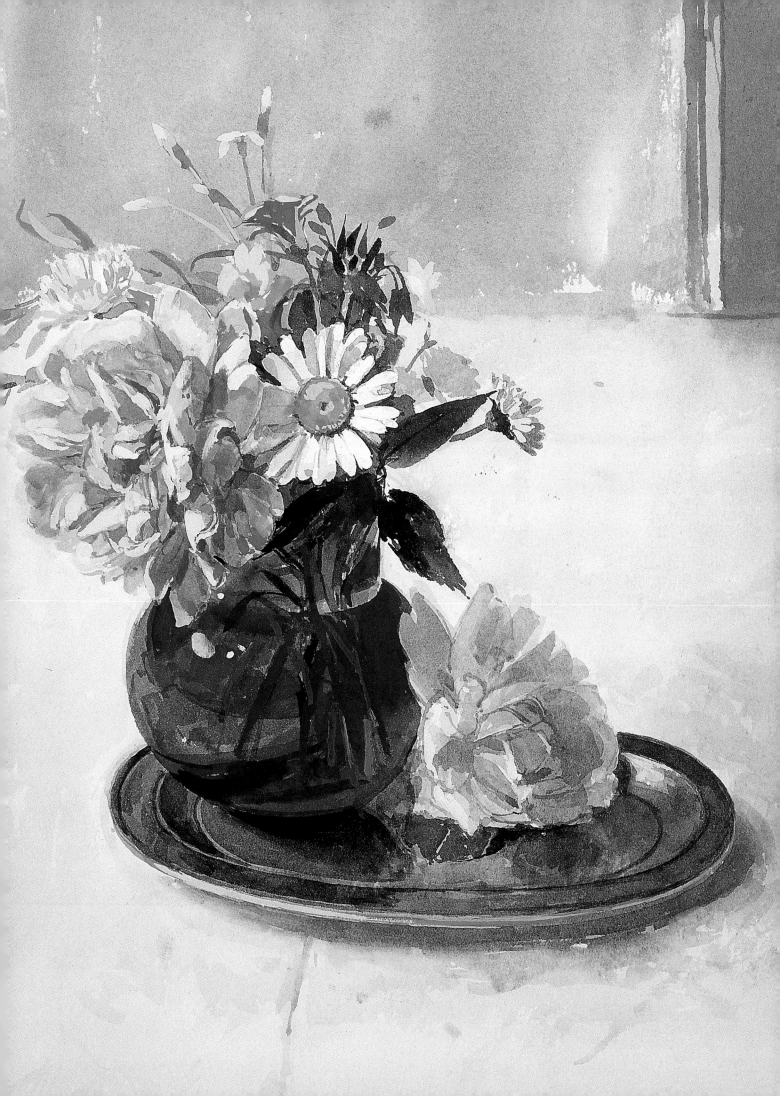

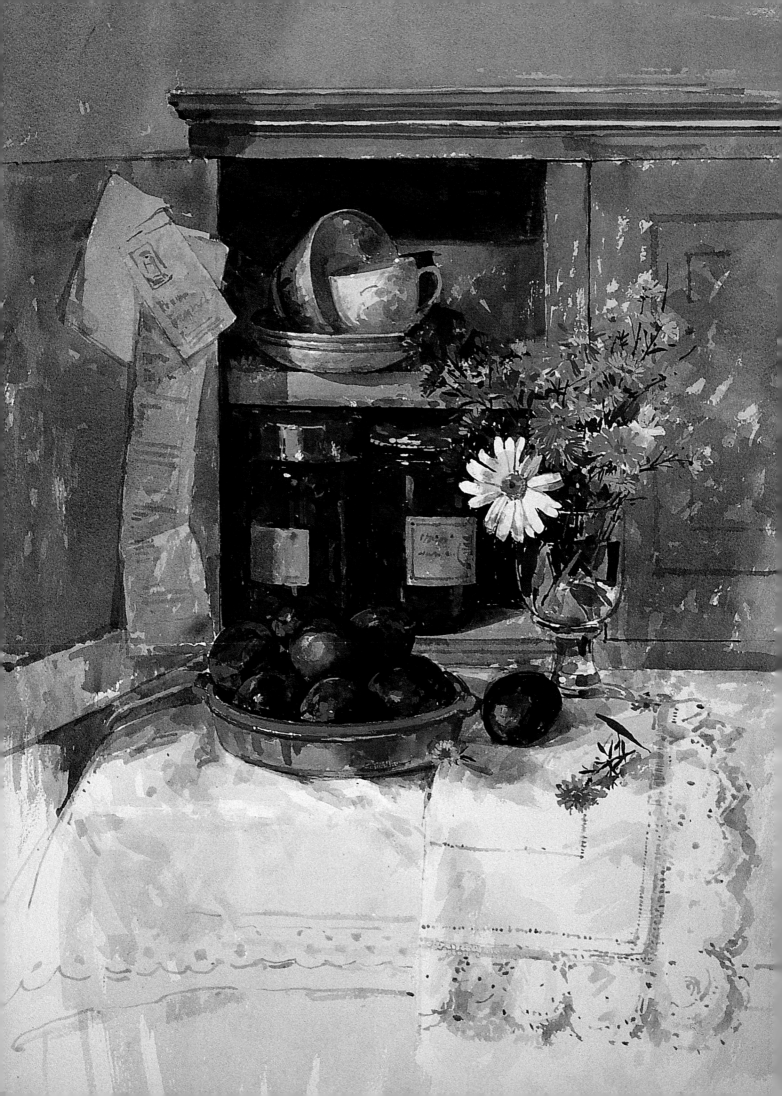

Although gouache has opaque fillers, nevertheless (and possibly surprisingly) it can be used in transparent washes in exactly the same way as watercolour: it can also be used opaquely and thickly in its undiluted pigment form, rather like oils in its handling – or any combination of the two.

Painters have very strong feelings about their own work and chosen medium. They are told quite dogmatically early on in their careers that there are rules and regulations and prohibitions to observe when handling various media. I distrust this profoundly. I hate being told what I can and can't do. The business of painting is difficult enough without more restrictions and is full of contradictions anyway because that is how life is, and painting is part of life.

Rules in painting are made to be used as a lifebelt: only any good for clinging to. It's much better to be swimming confidently than clinging uncertainly. Not surprisingly, I believe painting in gouache gives enormous freedom to do just this. The conventions and prohibitions hedged around pure watercolour, and which make it such a virtuoso medium of long tradition and application, simply are not the same for gouache. It is a very amiable medium that will stand up to bullying, nagging and neglect. I can't think why it repays such treatment so handsomely.

Painting in pure watercolour involves a transposition of reality. It is never quite possible, except in the most gifted hands, to achieve a fair correspondence of colour and tone when working, for example, on still life in this medium. The depth and richness of tone is difficult to achieve. I find that gouache, on the other hand, can give a greater depth of tone, closer to that which can be seen in reality. I do not suggest for one moment that watercolour painting should be abandoned in favour of gouache. This is not missionary zeal or fanatical conversion: many find it impossible to change media, having worked hard with one that suits them and which they find comfortable. I enjoy gouache because it suits my work as well as my temperament. It has to be a happy marriage, or it won't be successful.

For me, gouache achieves all that watercolour can and more. It does so quickly, with greater precision and at my speed. Washes of transparent gouache will give a heavily saturated area of colour instantly. When it dries, the tones will be still quite close to the original strength of the wash, unlike watercolour which dries much lighter. Opaque gouache, however, can dry chalky in colour if the mix is too overloaded with white, so mental adjustments must be made and care taken. Just as a mental allowance is necessary when using watercolour, so also is it possible to learn how to gauge tones to allow for the specific behaviour of gouache.

It does give greater precision when used quite opaquely with a fine brush for drawing, in the final stages of a painting. I do emphasize, though, that this is a very personal matter, just as the choice of paper to work on is equally personal. The right surface and quality of paper is vital.

Finding the paper that 'feels' right is as important to me as having a good doctor and dentist. It's part of my life-support system. There used to be a sensational paper called 'Kent' that I always used until the mill burned down. Papermills seem to be particularly prone to disastrous fires. The loss of Kent paper was a severe blow not only because the quality of paper was destroyed for ever, but the felt beds it was made on went as well. It can take years for the beds to 'wear in' to give just the right surface to the paper made on them.

Russell Flint is known to have rifled unashamedly through every sheet of paper in art

Opposite
PLUMS, PRESERVES
AND MICHAELMAS DAISIES
*Gouache, 21x18in
(53.5x46cm)*

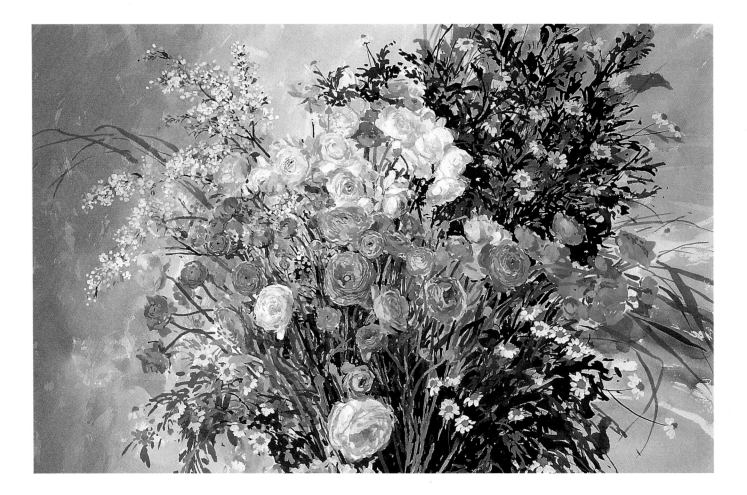

YELLOW AND WHITE
RANUNCULAS AND DAISIES
Gouache, 20x25in
(51x63.5cm)

material shops in order to select just the right surface with the precise finish he needed. For him it was like discovering fine wines amongst the *vins ordinaires*.

New felt beds, as Jim Daler himself kindly explained to me once, give a quite different, more pronounced textural surface quality to machine-made paper, and it does take some time for the 'mechanical' look to wear off. I wait patiently because I use his paper.

Initially, I tried many different papers unsuccessfully. Some were too highly sized; some took the wash as sympathetically as painting over barbed wire; some were under-sized, and soaked up water like blotting paper. Painting on these surfaces was like roller-skating in deep sand. Some seemed to have an oily film over them. It was extraordinary.

The weight of the paper played an important part, too. Heavyweight sheets that were almost like cardboard had no responsive 'give' to them at 300lb, while 90lb needed stretching; 140lb had a surface like the skin of an adolescent youth – all bumps and craters – even with a Not finish.

I despaired and settled finally for Daler's 'Saunders Waterford' 90lb Not finish paper as I always stretch my paper anyway, and this had the nicest response to its surface. Whichever paper you choose, it matters above all else that you are comfortable with it, otherwise it will show in the work.

In the main I use only three different brushes: a No4 and a No6 Rowney Kolinsky Sable for drawing and laying-in, and a fat Chinese wash brush to cover large areas very quickly. It is a modest outlay.

No expensive equipment is needed to paint in gouache. For a palette I have an old

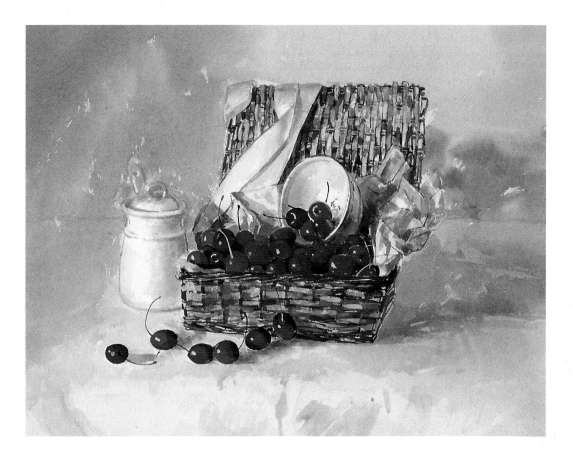

BASKET OF CHERRIES
WITH CUPS
*Gouache, 12x18in
(30.5x46cm)*

Cornish ware blue-rimmed dinner plate. Any old large china surface will do: it's just that I'm very attached to this one. It stays on my trolley in the studio with encrustations of colour round its rim. There is a second plate, an all-white china one, which is kept for permanent white gouache and its mixes of opaque colour only. The transparent colours stay on the blue-rimmed plate and I try not to contaminate them with white.

The range of colours I use are: lemon yellow, spectrum yellow and golden yellow; cadmium yellow deep (which is orange), and marigold yellow (which is also orange). The reds are flame red which gives a bright orange red and alizarin crimson for the blue end of the red range. Purple lake – a reddish purple – and spectrum violet – a bluish purple – sit next round the rim, following on with ultramarine blue, jet black, olive green, burnt umber, burnt sienna then raw sienna which completes the circle round to lemon yellow again. I occasionally use raw umber, but this granulates in washes and is not a very agreeable colour – a nappy brown which I would rather forget.

There is a huge jam jar of water which keeps the water as clean as possible until all the transparent washes have been laid-in. Once opaque pigment contaminates the water jar, it kills the chance of a later clean wash.

I prefer to use gouache just as I would use pure watercolour, beginning with pale washes to establish broad colour areas, drawing with the brush throughout. Gradually I raise the tones to their proper depth and take both colour and tone as close as I can to whatever it is I am painting.

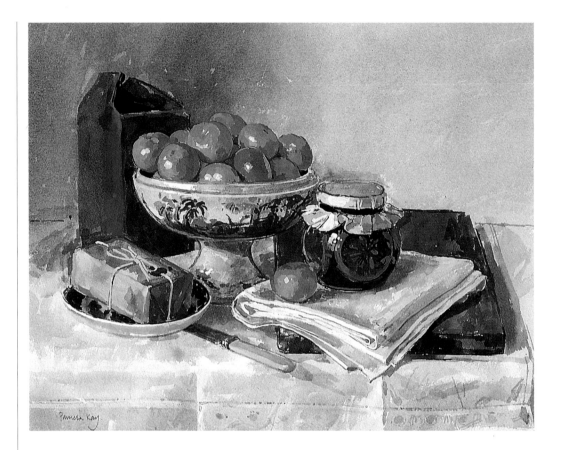

TUREEN OF MANDARINS
AND PRESERVES
Gouache, 13x18in
(33x46cm)

This approach may begin in the same way as that of a watercolour, but it progresses to a closer approximation of an oil, the tones getting darker and, where necessary, the pigment denser. The tones are as accurate as possible and so is the saturation of colour. Any refinement of drawing or rescuing of light areas over dark grounds is easily achievable with opaque pigment. Gouache is remarkably versatile as a medium and allows you to take paintings further and further, more so I feel than with pure watercolour.

Bear in mind that there is no 'right' way of painting a picture. This is a very general view of how I approach the work. It may be that a flower painting will demand an early completion of a particular flower or mass of flowers because they are going to die fairly rapidly. It may be that an even, all-over building up of lights and darks and richness of colour can be made more slowly, in a considered way, when painting a sedentary still life.

It may even be necessary to lay-in background colour washes of some intensity and variety, as in a painting of a garden, then flail about scattering colour – transparent and opaque – on top in an attempt to make some order out of the chaos that confronts you. A predictable pattern to it all is mind-numbingly boring, and unsuitable. Far better to be taken by surprise, and to have to decipher the information assailing the eye anew each time to make it work, rather than paint to a formula. It keeps the work fresh.

The final stages of any painting is the pulling together of all the disparate parts by means of incisive drawing where it is needed. The drawing gives the emphasis. It is a focus of attention and other parts must be left softer and more nebulous. They have a quiet part to play so should not be heard above the main lead. A play doesn't have everyone on stage all the time shouting their heads off simultaneously. Neither should a painting.

It may be that a small rose was the very reason for picking up a brush. If so, then this thought should be conveyed by a more detailed handling of this flower than the rest. Rely on the intuition that sparked off the initial response.

It's rather like cooking. A wonderful matriarch I much admired was an intuitive cook. Ask her for a recipe and it would always be 'add just enough' or 'the right amount' of this, that or the other ingredient – never specific. Ask her how long to cook it and she would reply 'until it's done'. It was infuriating, but she knew what she was doing, and she was intuitively right. Sometimes I think painting should be like throwing out all the precise cookery books with gram measurements, and working by instinct, by the skin of the teeth, dangerously. But it can only be done successfully when you are at ease with the materials and fairly confident of the methods.

It is, of course, no help at all to suggest to people that this is how it might be done if they are absolute beginners. But I happen to think that there are many far more gifted painters around who have gone through the preliminary stages, and are ready to move on in their work, but need to trust their own instincts a little more.

A change of medium is always a difficult business. If it takes ten years to navigate the trials and difficulties of watercolour, why then should anyone expect immediate success with the first few months of using gouache? It is unreasonable and unlikely. Any process takes time and perseverance, and the work develops and improves slowly. It is important to have sympathy and affinity with the medium, too.

BASKET OF CLEMENTINES AND SPICED OIL
Gouache, 13¹/₂ x 18 in (34.5 x 46 cm)

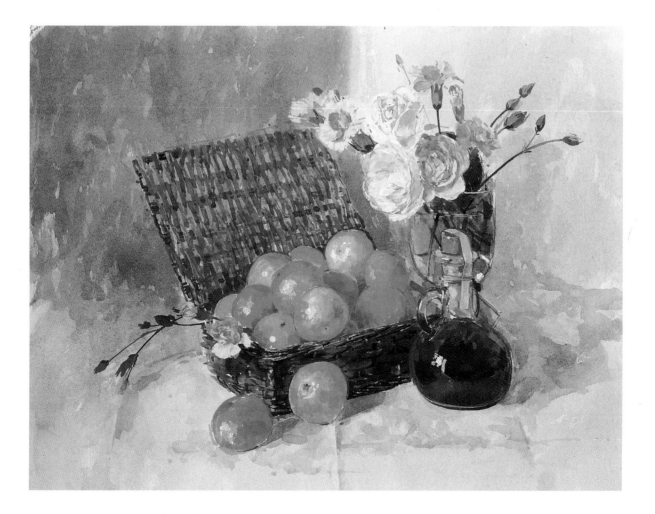

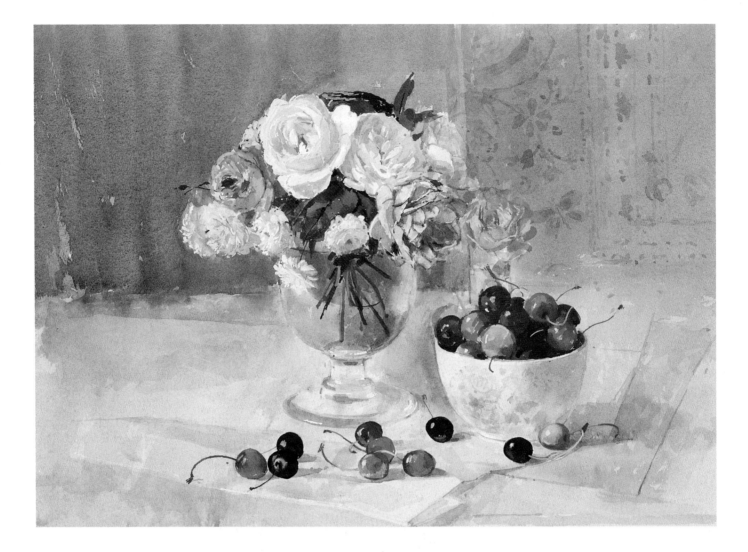

Above
VICTORIAN RUMMER OF ROSES AND CHERRIES
Gouache, 13x18in (33x46cm)

Opposite
LINDA'S EGGS IN A BASKET WITH A CREAM PANSY
Gouache, 14x10in (35.5x25.5cm)

Old-fashioned roses – 'Tour de Malakoff', 'Cécile Brunner' and 'Buff Beauty' – sit with an 'Iceberg' rose or two in a voluminous Victorian rummer. The pale pinks, reds and muted yellows and oranges in the roses are picked up and enriched by nap cherries.

There is a run of rich globular shapes. They curve across the arch of flowers, down through the ellipse of cherries, and are stabilized by those along the base line of the composition. Warm colours are balanced against the neutral greys of the background and table surface.

A warm oblong of sienna umber-coloured cloth on the right-hand side prevents too much grey from swamping the overall warmth of the colour scheme. It also acts as a strong vertical behind the group and prevents the whole composition from running over like fermenting dough.

The simplest arrangements can be the most effective. This small basket from Corfu was originally filled with preserved kumquats, but they disintegrated a long time ago leaving an unusual container like a small nest box. It seems just right for some straw and brown eggs from a friend's chicken. Right angles in composition are supremely elegant and the pot with the white pansy has just the right feel to it.

The brown egg on the table balances the white flower-head. The whole is based on very few colours and they are all of the same 'family'. Quiet circles and ellipses, careful geometry and very subtle cool and warm greys form the necessary scaffolding that quietly pins it all together.

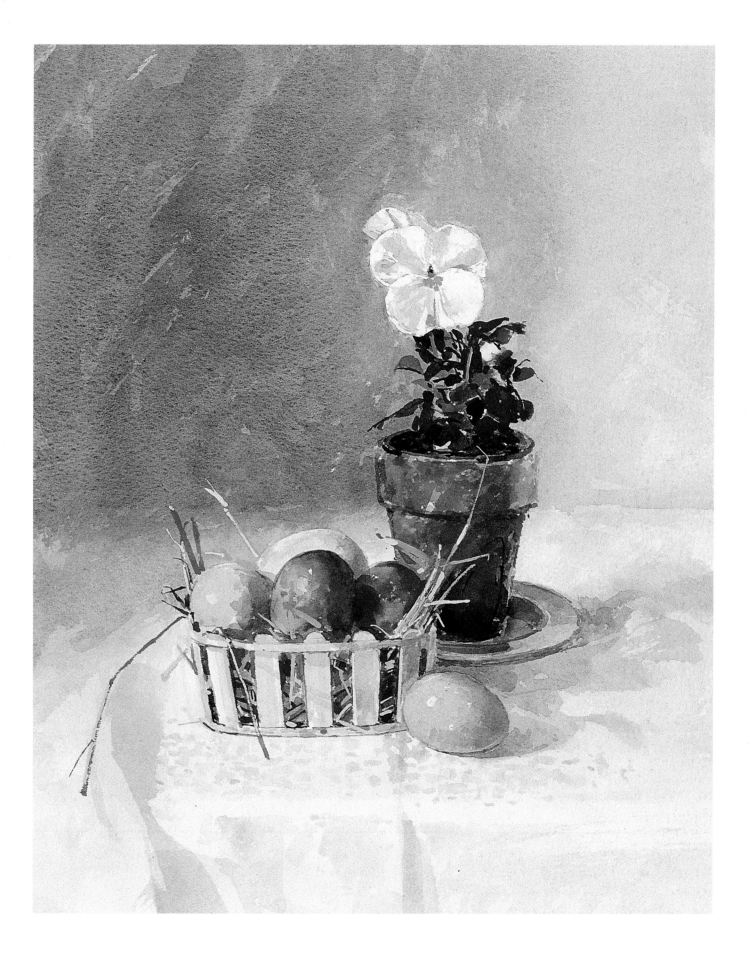

Some years ago, I enrolled at our local adult education centre to join an etching class. As a fine art student at art college, I wasn't allowed into the mysteries of lithography and print making. All these 'autographic' processes had been kept as a special treat for the graphic designers, mainly I think to cheer them up for not being allowed to do painting. I thought I should plug this gaping hole in my education.

After six weeks of rolling up copper plates, smoking them over candles and passing pheasant feathers across them in baths of acid, these arcane rituals completely finished me. I realized I did not have enough life left to live in which I could encompass all there was to know in order to produce a decent etching – and gave it up. Quite unreasonable, you see? If there is a moral to this disgraceful tale, it is that it's probably better if things slot into place of their own accord.

Have a go by all means, but if it doesn't work there are no prizes for beating your head with an artistic brick. There are other things to do. Unquestionably it is helpful to have an open mind when trying new media and all successful adaptations can only be achieved willingly and at the right time.

I well remember a lady watercolourist I met on holiday. She always used a pad of cartridge paper to work on.

'I did this marvellous view of Mount Etna seen through the backdrop of the Roman theatre in Taormina,' she said, 'and when I stood up, it all ran down the paper and was ruined.'

'Do you think,' I offered, 'it was because you were using cartridge paper?'

'Oh, I always use cartridge paper,' she retorted sharply.

BUTTERCUPS AND DAISIES IN
A SPODE CUP AND SAUCER
*Gouache, 7x9¹/₂in
(18x24cm)*

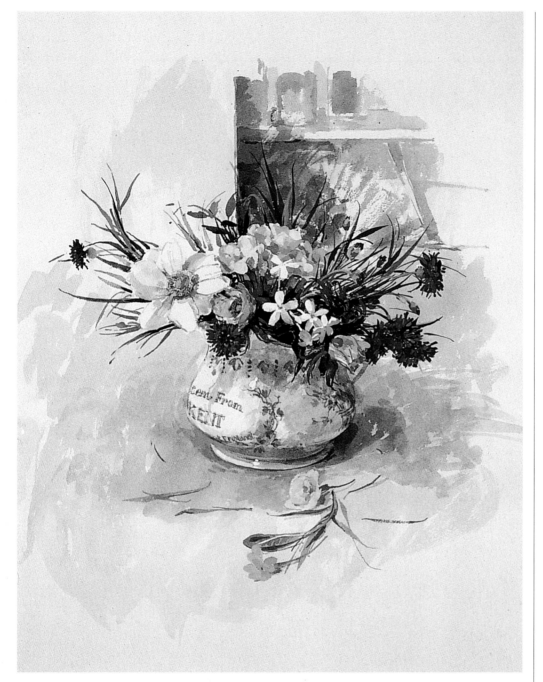

A PRESENT FROM KENT
Gouache, 18x14in
(46x35.5cm)

**A lightly handled series of pale
washes, this picture, executed
early in the year, shows a
severely limited palette of
colours.**

I suspect this will always be a problem for her. You can't get past a blinkered view, and to suggest using proper watercolour paper would not have gone down well.

To summarize, watercolour is a stain of transparent washes where the colour of the paper is left as the lightest tone. Gouache can be used in exactly the same way as watercolour but has the added advantage of being able to be used opaquely. The paper plays a different role because light tones can be painted on top of dark washes in opaque colour, should it be necessary. In addition, gouache can be used opaquely in a similar way to oil paints. It is a versatile bridging medium between watercolour and oil with few prohibitions. I love it, but you can only find out its delights by using it yourself.

DRAWING

n awareness of the importance of good drawing is at the very heart of using gouache well. The precision of line that can be achieved when using the medium in its transparent or opaque form demands good draughtsmanship. But then good draughtsmanship, close observation and tenacity are the raw materials for any painting.

Because I found watercolour too delicate, I also found it too imprecise for the things I wanted to do. Pushing a painting further and further and using the medium to draw incisively would only really work for me with gouache. Drawing is, after all, the foundation while painting is the superstructure. The foundation, whatever its form, is always the same – it has to be firm, durable and reliable. The superstructure can be anything you like, but it will be affected permanently and finally by what is underneath: the drawing.

Drawing is not simply making marks on paper. It should be an intelligent assessment of an observation. A good grounding in drawing is not just desirable: it is indispensable.

SLEEPING CATS
Conté

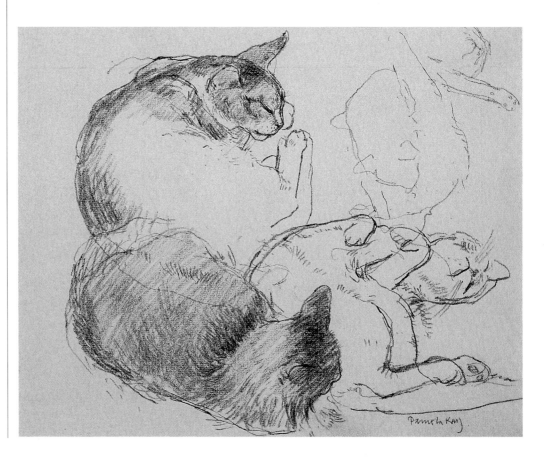

Opposite
THE HORSES ON SAINT MARK'S,
VENICE
*Pen and ink, 21x13in
(53.5x33cm)*

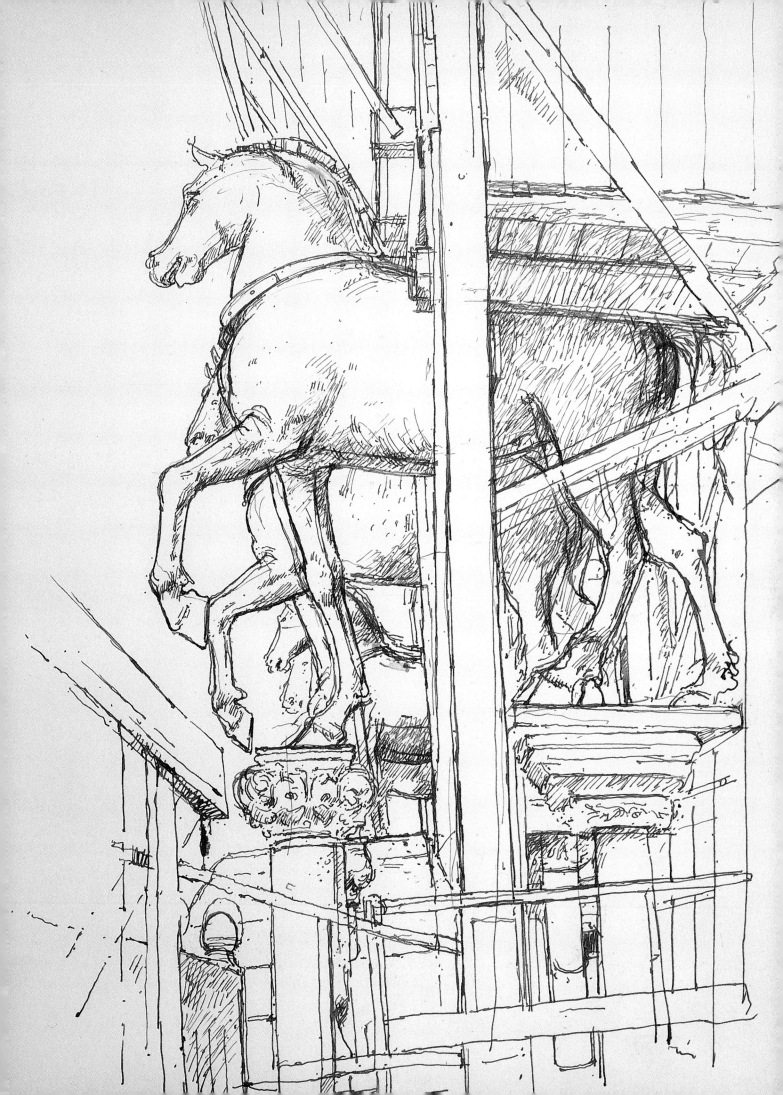

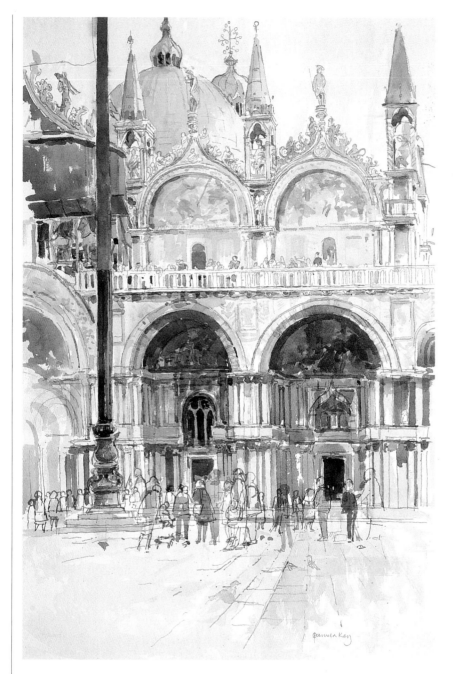

SAINT MARK'S, VENICE, EASTER
Pen and wash, 20¹/₂ x 13¹/₂ in
(52 x 34.5 cm)

A friend of mine once said with great relish, and a slightly sadistic gleam in his eye, 'I see lots of students with their portfolios, looking for work in my department [TV graphics] but none of them can draw. Do you know what I would do with them?' he asked (quite rhetorically, because he was going to tell me anyway). 'I would lock them up in a room and make them draw solidly all day for two weeks.'

This would be my idea of heaven, and I agreed that it would make all the difference to the quality of his students' drawing, so long as they had a good teacher locked in with them.

It helps anyone to undergo an intense period of concentrated work to advance their drawing, but the degree of improvement is in inverse proportion to ability: huge improve-

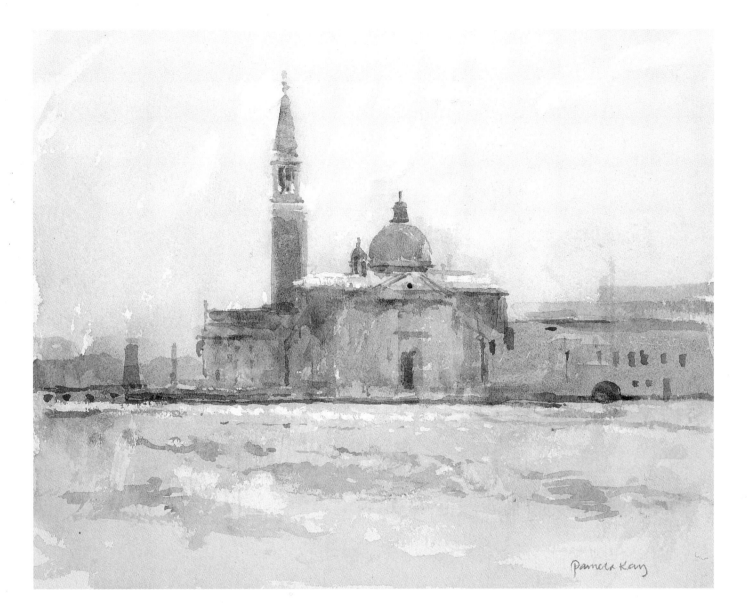

SAN GIORGIO MAGGIORE,
EARLY MORNING
*Watercolour, 9x11in
(23x28cm)*

ment for the beginner, narrowing strides as they get better. It is like physical exercises or piano scales – a limbering up that creaks a bit at first, then flows at the end.

Drawing is at the core of everything. It is the personal selection in a drawing or piece of work – what is left out as much as what is put in – that shapes every artist's personal 'handwriting' or immediately recognizable style. It is difficult not to be influenced by greater hands and better work; in fact it can be all to the good. To see with a better eye that belongs to a finer draughtsman is the passing on of a small insight that feeds one's own work. To copy that style slavishly as if it were one's own is not only a complete waste of time and effort; it is a negation of oneself and blocks the possibility of personal development; of owning one's own voice. It is a fine balance that must be struck.

Discipline and regular practice are at the heart of progress in drawing. Unfortunately, the hours of sweated labour in front of bulging life models that I relished as a student are encountered less and less often today in art schools. There are no short cuts, however, and a training that encourages drawing everything is invaluable. Flower painters should be able to draw people and buildings, just as landscape and portrait painters should be able

to draw flowers. There is no demarcation. If you can draw well, you can draw anything, because you have been taught how to see. Whether you have studied formally or not, the key to improvement and better understanding lies in constant practice.

This is unquestionably a counsel of perfection. Only full-time artists or students can give the time and dedication necessary to the constant practising of drawing. Nevertheless, as any devotee of yoga, jogging or gardening will tell you, thirty minutes a day of the chosen discipline is better than no time spent on it at all.

I spent a few days in the dark month of February trying to buff up my life-drawing with a group of keen friends. It had been some time since I last had the good fortune to draw a model and I rummaged for some odd sheets of cartridge paper and a charcoal pencil. After the gritty start that is inevitable with a change of discipline from painting to drawing, I spent the first day tooth-gnashing and slashing about through the dark jungles of neglect. The second and subsequent days were quite different.

Having fought my way in again, the drawings began to fall on to the paper with seductive ease, and the paper surface took the line with an almost uncontrolled Rolls-Royce

purr; an oddly dangerous situation. By now this was a different paper I was working on, and I was slightly mystified by the results.

At the end of four sessions I looked more closely at the paper I had been using with such profligacy and found that it was the finest original Ingres, the real thing that I had forgotten I had, and wished I still had. They simply don't make paper like that any more, and it makes an enormous difference to the feel of the work.

A certain sensitivity to the media and its supports is vital. So often drawings and paintings fail from the outset because the paper is unsympathetic; too smooth or shiny, too heavily sized or too rough on the surface. It's possible to plod on, determined to do something with it regardless, but it is not a battle that can be won, and the difficulty is in not knowing why.

The great benefit that I noticed after my four days' life-drawing was an improved sharpness of the eye, and a quicker response to the possibility of new work and new paintings. Familiarity dulls the edge, and although beautiful objects are still beautiful, the eye can become tired and unseeing. What used to please can begin to look commonplace and ordinary. The light goes out of it.

HEAD OF GIRL
Pencil

POTATO OVEN ON A CART,
ALEXANDRIA
Pencil

If there is a check in the work or a problem, it can usually be alleviated by returning to a period of drawing. It takes a fairly obsessive determination to keep trying until something works and breaks the log jam, then to build upon it – whether it is finding just the right paper that suits your work, or even the right kind of pencil.

It also helps to know if you are more of a draughtsman – thinking and working in a linear way, keen to define it all with an encompassing line – or perhaps more of a painter. A 'painterly' approach to drawing concerns itself more with the tones of things rather than their precise outline. It is more atmospheric and amorphous in appearance; things merge and emerge one from another. Tonal drawings have, surprisingly, great colour.

Whereas it would be possible to transform the information contained in a precise pen drawing into a 'map' plotting the exact location of the objects, to do so with a soft charcoal tonal drawing could prove more difficult and harder to pin down.

The change of discipline from constantly painting (although a form of drawing) to drawing itself can act as a lightning conductor for difficulties in the work. The limitations of the new medium check well-worn habits and familiarity with the practice of painting.

There was something almost exhilarating, I remember, in making a pastel drawing one summer of some lilies in the garden – *Pots of Lilies and Daisies*. I rarely use pastel and the change of medium was so novel and strange, the impossibility of achieving exact colour correspondence, made pastels – or any drawing – almost akin to translating something into a foreign language. Every thought and observation had to be transposed and considered. I recommend it.

Drawing is the most important tool of the trade. It is the foundation that the work is built upon; the basic beginnings. As a student, the basic beginning for me was the sketch

Opposite
POTS OF LILIES AND DAISIES
Pastel, 24x18in (61x46cm)

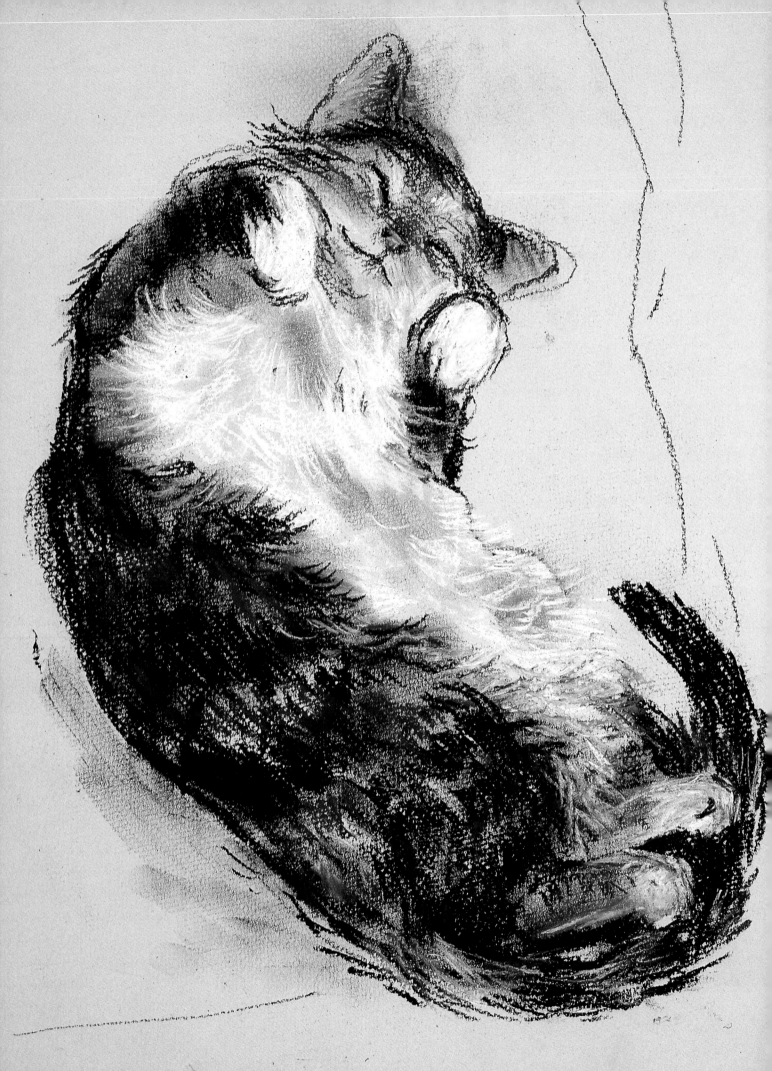

Pamela Kay.

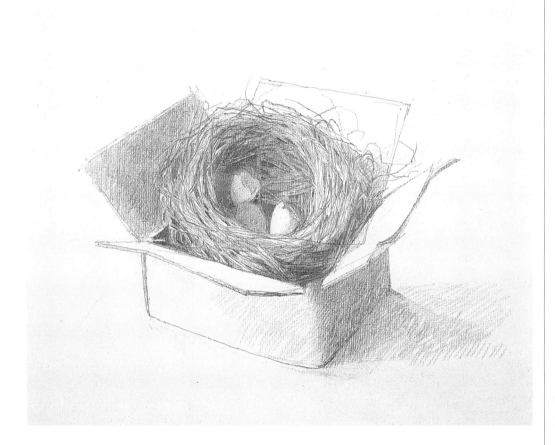

NEST IN A BOX
Pencil

book. I was taught that using a sketch book constantly was the best way of keeping the eye alert and seeing. I still keep one, but sadly not with the same intensity. It is not as easy nowadays to use them in public, and it helps if you can cultivate the art of invisibility.

In those days the sketch book was with me always, at the end of one arm, a permanent companion. Urged to draw everything and anything, it was a means of making us aware of our surroundings. Fresh from the rigours of O levels (it was desirable and possible to get out of grammar school as soon as we could and leave A levels to the intellectuals) suddenly lamp-posts and street furniture took on an unexpected fascination.

Drawings of old men asleep over newspapers in the local library (Daumier-inspired), backyards, boat-yards and still Victorian railway stations filled our every waking hour – and our sketch books – in the 1950s. There were around us remnants of undeveloped England, fragile architecture still standing years after the ravages of war, intimate alleyways and overgrown allotments. These were marvellous things to draw, but are harder to find today. Architect-designed housing estates leave much to be desired visually.

Recording something at a great speed, as it happens, is all sound observational training. A soft 6B pencil and a sketch book of well-sized toothy cartridge paper is ideal for a quick note in a special garden for a later painting, or recording an oven for baking sweet potatoes on a cart that I saw outside a mosque in Alexandria. It is a curiosity.

I still keep a sketch book and use it to note down things I find fascinating. Every trip abroad has a sketch book with drawn observations at one end and a diary written at the other. In the main it is so enjoyable simply to draw for the sake of drawing that I use my sketch book most when travelling, as others would a camera.

Opposite
SLEEPING KITTEN
*Pastel, 16x11in
(40.5x28cm)*

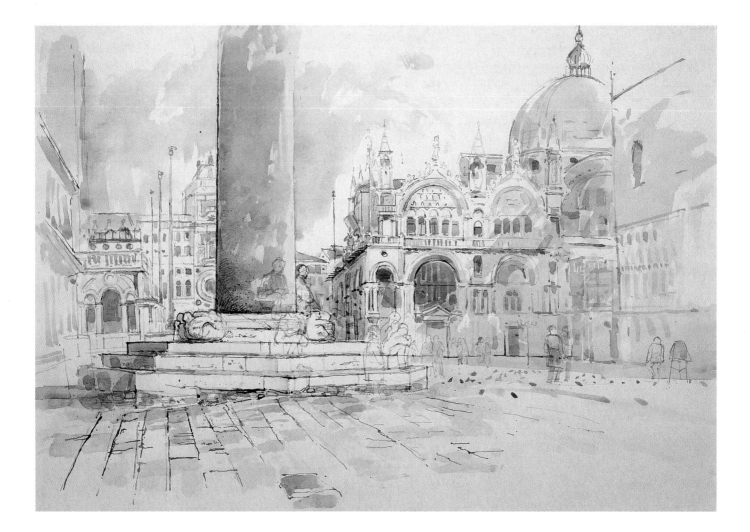

THE PIAZETTA TOWARDS
SAINT MARK'S, VENICE
*Pen and wash, 12x17in
(30.5x43cm)*

The pleasure I had in using a sketch book as a student has translated itself into a pursuit in its own right. Usually, sketch books are considered a means to an end; making drawings that will be used as preparatory notes for something later. An observation of how someone sits when bored or vacant, the intimacy of two people together, or the composition of a mass of cottage garden plants against the wall of a house, that will come in handy in a painting; all make useful drawing information.

However, there is no easy path, no instant skill. Instant skill is a slick drawing, all technique, devoid of any feeling or uncertainty; a flash whistle across the paper that says 'Look how clever I am'. Distrust this. The drawing that is fast, direct and right first time with an economy of effort and line, is either beginner's luck (and no less a blessing) or, more likely, achieved as a result of the accumulated legwork that has already been put in over the years. Rather than a sudden flash of inspiration, it is a release of controlled energy that crackles with its own spontaneous life. The knowledge of drawing is packed solidly behind it, so a line conveys simultaneously form, weight and authority. The speedy slick line is only that: all shallow effect, no form, no substance – a fast lick of Brylcreem on a very thin thatch.

Drawing is unquestionably difficult, clumsy at times, sometimes long-winded and slow. It will show every thought, every change of mind, every unsure probe and rethink. It may be a palimpsest: days of drawing rubbed out and reassessed. If it is all of these

Opposite
SANTA MARIA FORMOSA, VENICE
Pencil

things it is almost always accompanied at the end by a great sense of achievement, hard won and satisfying. It should be valued for the effort it demands.

Curiously, it is only then, at the end of concentrated study, that a line drawing of great beauty and economy might be done. The eye is so in tune with the hand that a sharply observed turn of the head can be summed up in a single line on the paper. Both approaches to the practice of drawing are valid. The long, intense study and the sudden, sharp sketch come together, not in isolation, and never one without the other.

Drawing is part of painting and really cannot be separated from it. Whenever you put a brush to paper or canvas, you are drawing. However broad the sweep of the mark, it is still drawing. Precision in drawing isn't a matter of intense niggling details, a congestion of black lead that picks out every last facet unselectively. It should convey information in the most concise way possible.

Painting in gouache allows for an even more intense use of drawing in a watercolour medium. The delicate brushmark in a Pissarro cityscape is sure and precise and in exactly the right place. It may be in oil, but it's still well drawn. The softly 'written-in' centre of a centifolia rose in a Fantin-Latour is the culmination of his knowledge and study of roses through endless drawing practice.

I was very fortunate to have been taught by exceptional draughtsmen. They demonstrated the unchanging truths of the craft and passed them on generously. The

educational system was working at its best, unfettered by any outside interference, and a single-minded view of work and its needs prevailed. Schooled in the best traditions, the early disciplines reinforced every aspect of the work and I still return to the practice of concentrated drawing when the need is there.

For example, there came a time when I wanted to stop everything and approach still life from a slightly different point of view. I changed medium and began the drawing of *Still Life with Onions and Apples* (page 56).

This drawing was hammered at for nearly a week. Charcoal pencil and toned paper with small touches of pastel make it slightly more interesting to do than a purely monochromatic one.

REBECCA WITH HAT
Pencil

Opposite
BUTTERCUPS AND DAISIES WITH APRICOTS (detail)

This painting appears in full on page 61. There are only a very few weeks in the year when this group can be put together. The buttercups don't flower for very long, and in a dry year their season is even shorter.

Buttercups and ox-eye daisies are the simplest yet most elegantly humble flowers, and their gently wavering stems come as a welcome relief after the stiffness of spring flowers.

This group is made up of colour 'families'. The yellows and oranges, picked up in the apricots and their basket, contrasted with the blue of the china and cool grey neutrals. The green, of course, is the mix of the two. You really don't need many colours for a painting to succeed. Sometimes it is better to restrict severely the main colours in the palette.

The most interesting part of this painting, for me, was working on the stems in the glass of buttercups. Not only do they have to look like a very complex arrangement of vertical lines, they also have to look as if they are in a curved formation and behind glass.

This is only achieved by very close observation, and then a certain generalization. It is neither desirable nor necessary to copy slavishly every single stem. It would drive me mad. The essence of what is there is what is vital, and selection and refinement must be the key.

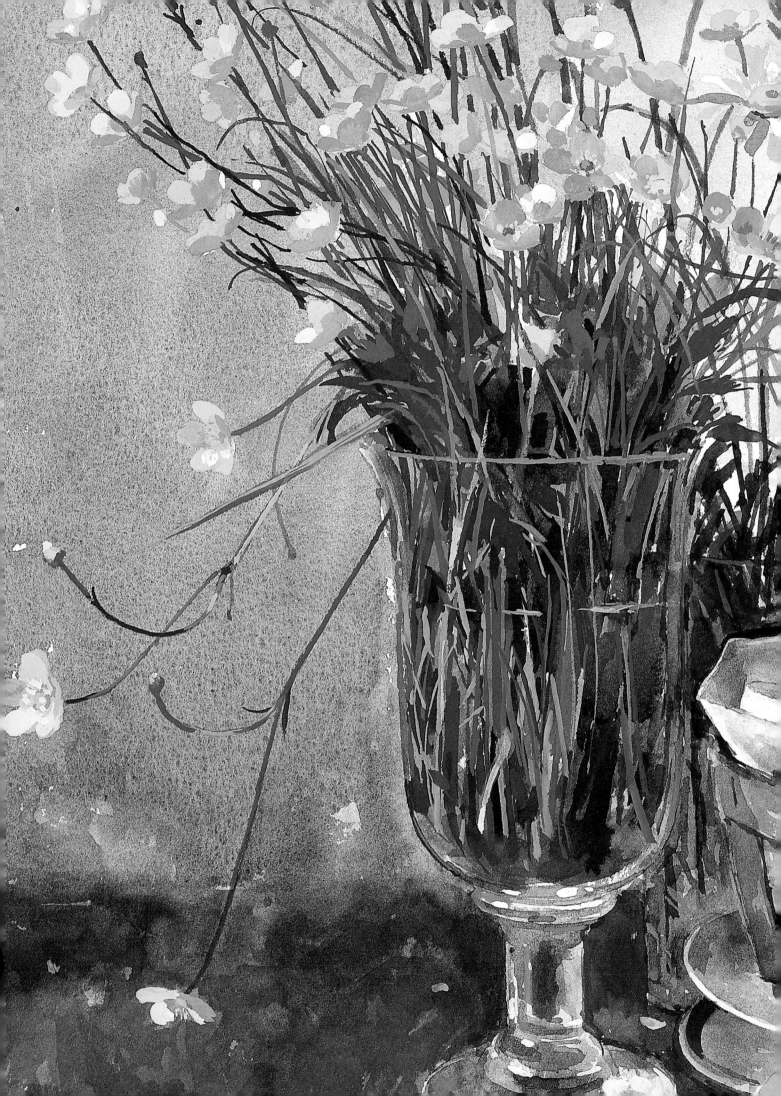

I set up quite an ambitious composition using my favourite bowls, jugs and basket. It is unintentionally full of pairs. I spent a day or so arranging and re-arranging the positions of various things instinctively, not really knowing what was going to happen, then left it overnight to settle. The following day I bought the apples and onions, added them to it, and it all came to life. A little more reshuffling and it 'felt' right.

The paper is a full-sized sheet of Ingres or Canson or some such, which takes charcoal and crumbly pastel well. I began to draw, lightly marking the areas of things, and kept on drawing and rubbing out with a putty rubber until I got it right. At least as right as I could manage.

Each object is a marvellous sheet anchor from which to measure the distance and size of the next, and having progressed crab-wise, slowly across the paper from left to right, it all began to relate.

BOO!

NO SMOKING

marines' panto
Deal Feb 84

Working from one object to the next, but very lightly, the whole composition was set in place. Everything had to be very gently indicated in order to provide a network of locations that could be confirmed or adjusted. The diameter of the bowl needed checking against its height. The eye constantly refused to believe it could be that big, and wanted to make it smaller. How high was the bottle compared with the diameter of the bowl? How large is the basket compared with the height of the bottle? If the bottle is wrong, so will the basket be. The objects must relate accurately to each other.

If there is one major mistake, all the calculations fall like a house of cards. Does the thing 'feel' right? Are there any glaring inaccuracies? By holding the drawing up and looking at it reversed in a large mirror, bottles that lean like the Tower of Pisa suddenly jump off the paper and shout at you. Table surfaces that list at an alarming angle become immediately apparent.

Drawing is all about seeing, correcting, redrawing, making decisions and selections – and educating the eye. It can be a humbling experience also, admitting that things are wrong, and being prepared to attempt to put them right. So often people are reluctant to 'spoil' a drawing or painting. This is the stage at which in reality you admit you are not prepared to go any further.

The next step, that of taking a drawing further, when you're not sure what should be done next, takes courage of a very high order. It could result in the destruction of hours of work or the realization that a successful outcome could shift your knowledge on to a new level. But this is best done gently, one step at a time, with conscious deliberation.

The decision I had made was to do a large drawing and take it as far as I could. Not simply a line drawing but looking intently at the tones of things as well, appreciating the 'solidity' of still life.

VICTORIA
*Conté, 7x9³/₄in
(18x24.5cm)*

Opposite
STILL LIFE WITH ONIONS
AND APPLES
*Pastel and charcoal,
21x26in (53.5x66cm)*

57

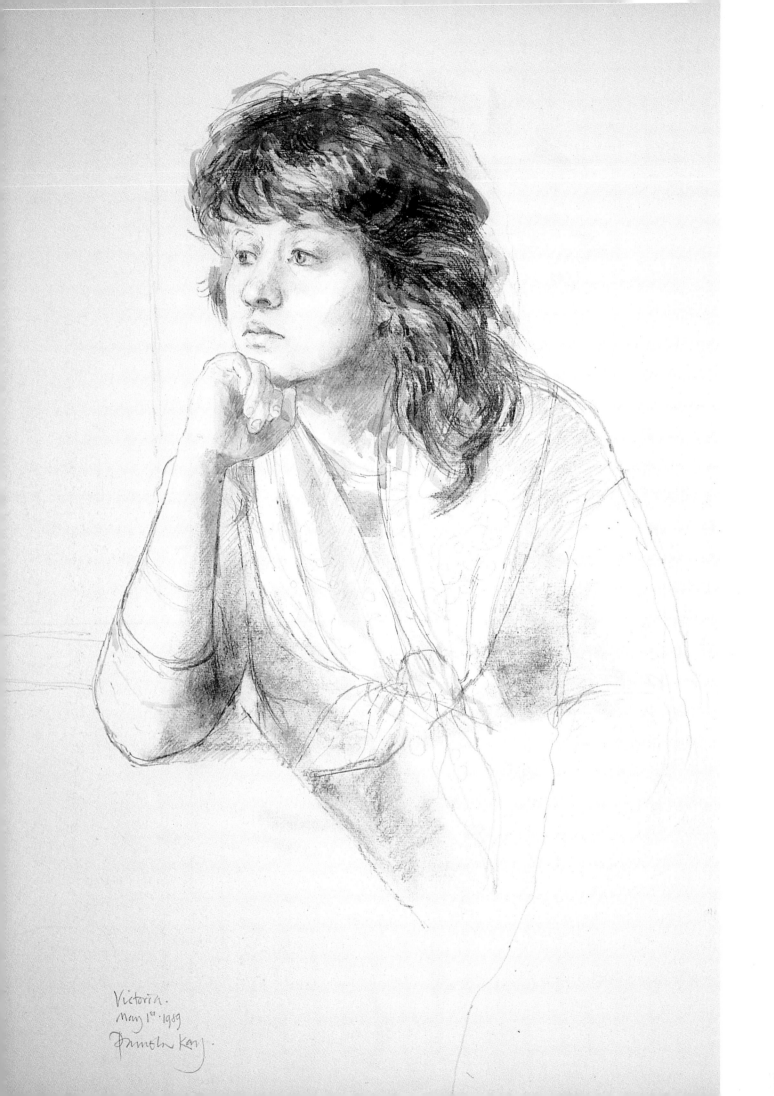

Victoria.
May 1ˢᵗ 1989
Pamela Kay.

The addition of colour came subtly to enhance the drawing but did not compete with it. In the main, it is limited to white (which helps to establish the plane of the foreground on the table-cloth), a brown/olive for the russet apples, and pale orange/sienna on the onions. There is some cool grey behind the jug and onions and the background. It takes very little colour to transform and lift the life in it, and too much colour would have turned it into something quite different.

It was a concentrated piece of work, but one that I felt should be a series of drawings if I were to achieve anything worth while. It was only the first and I still had a long way to go. There were parts that had been overstated through uncertainty, and other parts I thought had just the right emphasis: par for the course for most paintings and drawings. I felt that it had been time well spent.

Drawing is at the heart of everything. Much neglected now in the formal training of students, it has been replaced by the demands of a technological revolution, and computers play a large part in the design world today. The last bastion of drawing is still with the creative artist. It is the last means of developing a singularly personal expression. The only physical aid is the pencil, pen, sharpened stick or brush. A truly personal signature and style can only come from the constant practice of drawing.

STILL LIFE

Still life, as a subject for painting, has always fascinated me. I have no idea why, although I have always loved 'things' – cups and saucers, jugs and bowls. Perhaps because of my training, I am used to the thought that you draw what you see, so it follows that you paint what you see, and still life is a study of what is actually there in front of you.

It seemed very simple at the time. The angst of intellectualizing art was about to begin in art schools, but I was too steeped in Sickert, Stanley Spencer, Ruskin Spear and the French Impressionists to care too much for Jackson Pollock (although his style of dribble painting made marvellous textile designs, I recall).

The tradition of English figurative art spoke volumes as far as I was concerned, but so few painters bothered with still life, and it was very difficult to find examples to learn from. Even fewer in watercolour. Given a very low place in the pecking order of desirable

CREAM CUP AND GLASS
JUG OF FLOWERS
Gouache, 9x10½in
(23x27cm)

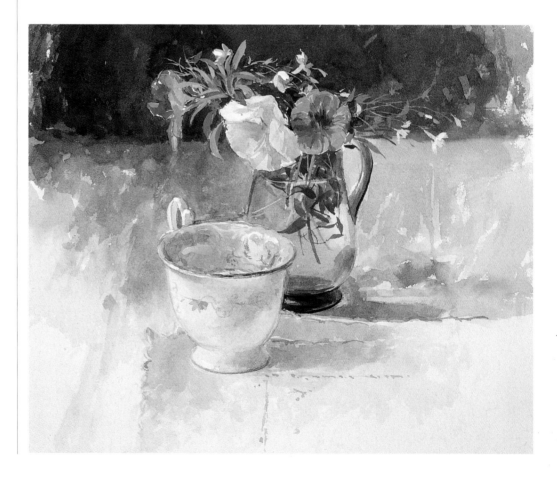

Opposite
BUTTERCUPS AND DAISIES
WITH APRICOTS
Gouache, 22x18in
(56x46cm)

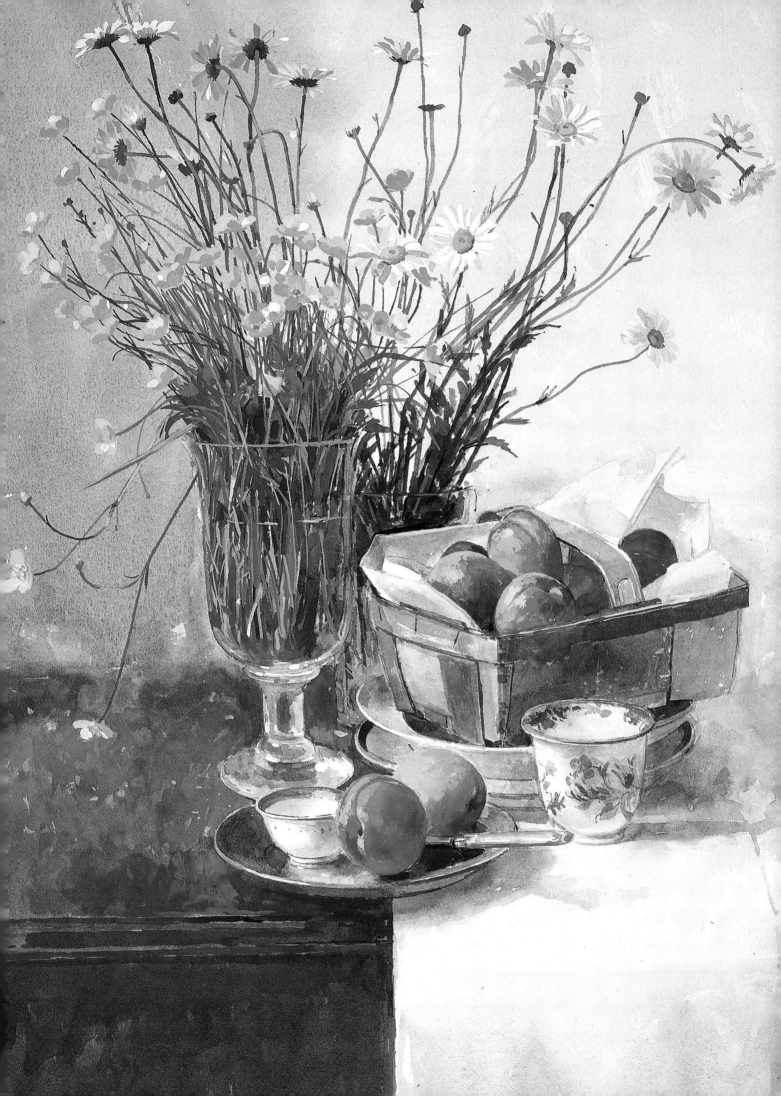

subject matter, its value in art schools was only ever seen as an 'exercise'. Cézanne set the tone for the study of still life, and the typical grouping of subject matter.

My student still lifes were marked by the progressive disintegration of the 'background cloth'. It was once plum-coloured velvet (the other one was brown) but its grey clouded nap fought a losing battle with raffia-wrapped Chianti bottles and the very dead onions placed in front of it.

In fact, my college days were punctuated by the same bottle of wine (sadly empty) and a group of wilting vegetables that were only grudgingly obtained after Herculean wrestling with the owner of the college petty-cash tin. It didn't inspire confidence. In fact, it didn't inspire anything at all.

The idea of setting up a group of mainly rubbish trouvé in front of a piece of drapery, in emulation of the fine Cézanne, was deadly. Ostensibly to demonstrate the relationships of things one to another, the proper assessment of tone, the effect of light and the harmony of colour, it sat there for days on end, unvarying, predictable and a test of stamina for the most hardened optimist. It is sad that it was only thought of as an 'exercise' and 'good for you' – rather like Eno's fruit salts.

There was no need for it to have been so dispiriting, but it relied for its variety on the contents of the 'still life' cupboard. This was a rubbish bin of ancient hurricane lamps, old boots, bits of animal skulls and rejected bric-à-brac. Everyone's painting looked the same, and all were equally laboured and self-conscious in a disinterested way.

As a subject, still life came quite naturally to me, in spite of its grisly start. I have always enjoyed painting directly from the motif, and find it difficult to do studio paintings from the imagination. There is enough for me in the world outside that is fascinating without delving into inner depths, and a table of food and china was more than sufficient for an interesting painting.

The Royal Academy of Art put on an extensive exhibition of Dutch and Flemish paintings of the fifteenth and sixteenth centuries when I was about fifteen years old which forever afterwards influenced the way I looked at things. The main galleries were full of exquisite still life and flower paintings.

In the room devoted to Breughel were hung the 'Icarus' and 'Tower of Babel' series and, opposite, a grand painting of a marriage feast which showed a procession of servants, carrying to the table vast trays of food balanced on their heads. The woman standing next to me surveyed this particular painting with interest, turned to her companion and said, 'I went to a wedding recently where they did just that – brought it in on trays on their heads and, do you know, the food was stone cold by the time we got it'. Some things never change.

I remember vividly being stunned by the quality of Dutch still life and flower paintings. It was the first time I had seen any. The light and stillness, the sharp reality of the objects and their arrangement, came as a fascinating revelation.

Perhaps because of the privations of World War II, when I was a child, the Dutch depiction of food was the motif that stayed in the mind's eye most indelibly. Sumptuous sideboards, trembling with lobsters, peaches, cheeses and nuts, breads and oysters, were as much a social document of their times as a work of art. The Golden Age of the Low Countries, a time of prosperity and generosity of spirit, favoured the creation of equally generous paintings. All this from a nation under constant threat of inundation that made life very immediate and real. Their pleasures and pastimes were ferociously enjoyed and displayed.

Opposite
BUTTERCUPS AND DAISIES
WITH APRICOTS (detail)

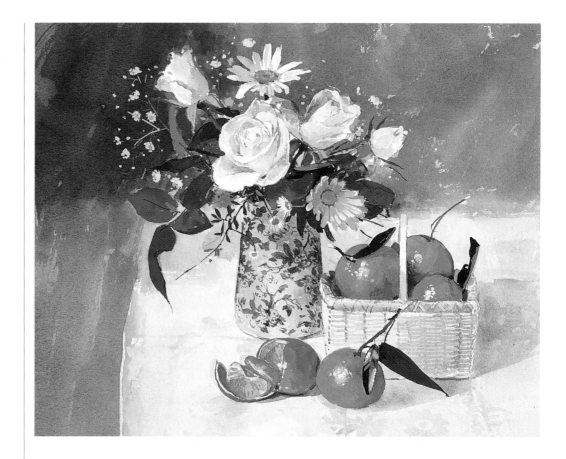

ROSES AND CLEMENTINES
*Gouache, 9¹/₂ x 11 in
(24 x 28 cm)*

I discovered the still life of the Dutch and Flemish painters years before I had heard of Cézanne, which possibly explains why I felt so disappointed at college. Given the tools of the trade and a sound grounding in drawing, I decided that it was up to me to find my own way.

Grasped by the idea of still life, the medium in which to work was secondary. Inevitably beginning with oils, the transition to gouache was simple and painless. Early in life I began building a repertoire of favourite objects to paint. The 1950s was a time of rich pickings in the backstreets of Canterbury, where the dark second-hand shops smelt of sour cheese, ingrained dirt and scouring powder. I never seemed to have quite enough money to buy a balloon-backed chair or a Georgian table, even when they were very cheap, but just managed to afford an old serving dish, a glass or a quilted bedspread and some well-laundered napkins.

My taste moved – *force majeure* – from the grand to the modest. I discovered the simplicity of the eighteenth-century French painter Chardin and dug in for a long stay. I couldn't afford to set up vast Dutch breakfast pieces on my parents' sideboard at home and whilst I could admire the virtuosity of execution and the distillation of light, indigestion set in and I turned to more austere fare.

The progression from Dutch indulgence to French parsimony worked well. You can't have too much of a good thing, someone once said, but in painting I think you probably can, and I discovered a small picture of a bundle of asparagus by S. Adriaen Coorte in the Fitzwilliam Museum in Cambridge which can be hung any way round and still reads perfectly. Not far away in the same gallery is a very simple painting of a cup and saucer by the nineteenth-century French painter Fantin-Latour, exquisite in its economy.

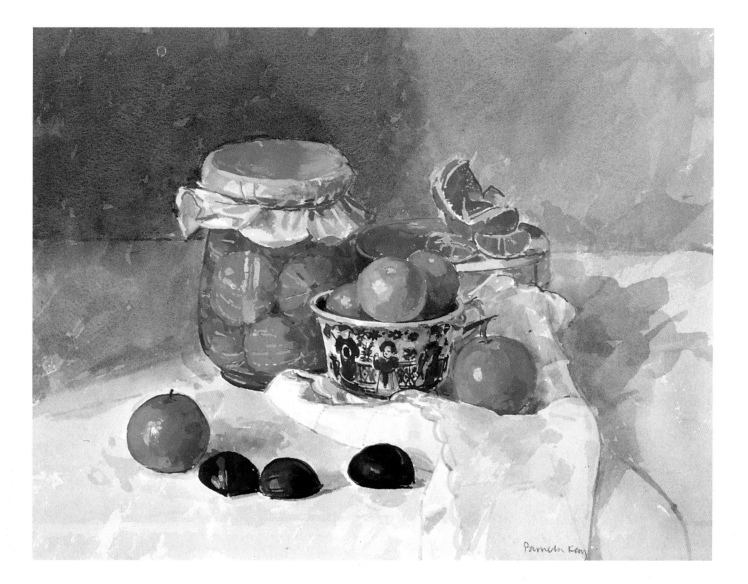

MANDARINS AND HILDICH CUP
Gouache, 10x12in (25.5x30.5cm)

This is one of the stages in working up to a larger painting on the theme of a marmalade still life.

A few related friends; the jar of preserved mandarins is painted thinly but lower in key than the fruit in the bowl, because they are behind glass. Washes of clear colour extend over the entire painting. Only when colour needs enriching does it progress to opaque pigment.

The orange on the cloth has a heavy overlaying of subtly changing hues to give it greater depth and solidity. The chestnuts have transparent but very dark-toned washes making up their shape; their volume is defined by opaque colour touches of grey/blues and warm pink/grey along the contour of the highlight. All is drawn-in with the brush to define areas where necessary.

65

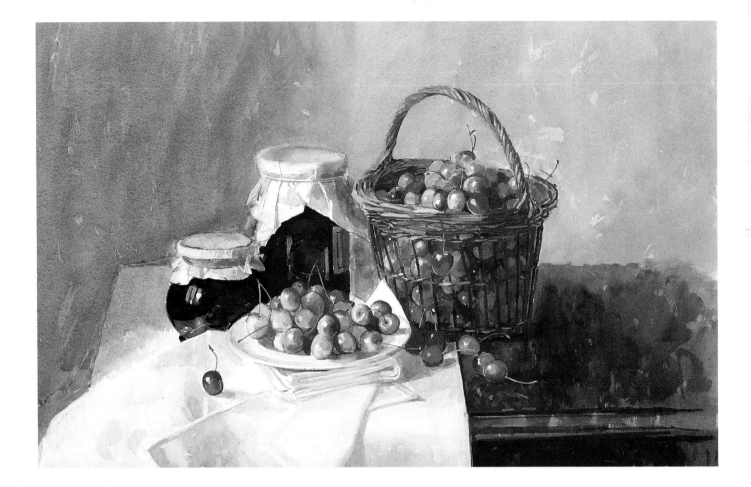

NAP CHERRIES AND PRESERVES
Gouache, 13x18in (33x46cm)

*The detail of this painting (opposite) shows the actual size of the
picture, which I think is always useful. It is often so difficult to
assess the size of a picture. Some of the most dramatic landscapes by
Turner, Cotman and Girtin look in reproduction as if they are in
reality huge works – they have such grandeur of scale. It is
sometimes a shock to see the original and discover that they are, in
fact, extraordinarily small in size, yet encompass such authority.*

*There is a rightness of scale and proportion in painting which
has to do with the subject and the mark of the brush. The plate and
basket of cherries assumed this size on the paper quite naturally.
Were they to have been very much larger in scale they would have
fallen apart, overblown, and weakened. Any smaller in size and
the whole group would look constipated and niggling.*

*I look long and often at the work of the eighteenth century
Spanish painter Luis Melendez who delighted in painting fruit
and baskets of almost agoraphobic intensity. The composition of his
oil paintings almost bang at the edges of their frames – so close is
his scrutiny of his subject matter.*

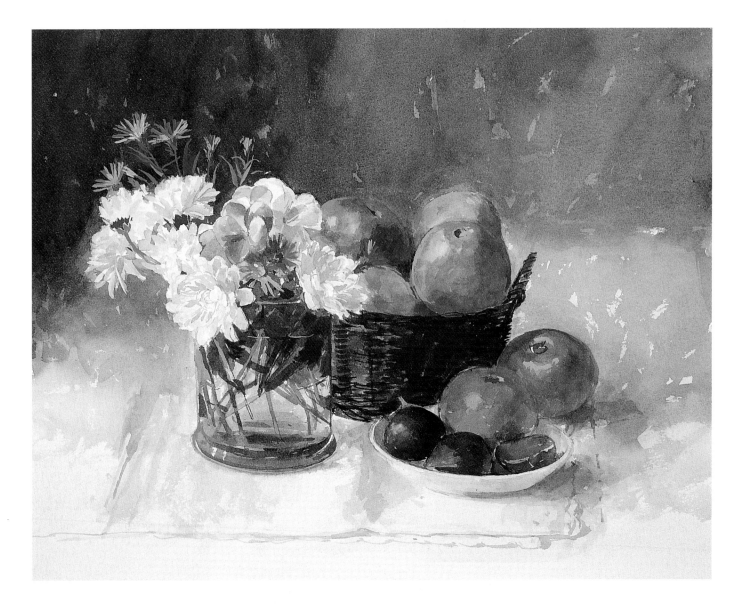

GLASS OF FLOWERS AND RUSSET APPLES
Gouache, 10x12¹/₂ in (25.5x32cm)

The depth of tone plays an important part in this small painting of flowers with russet apples. There is something suede-like in the matt olive surface of a russet that is warm and reassuring. It doesn't sparkle like redcurrants and is halfway to being peach-like in its surface quality. It provides a low tone in keeping with the chestnuts and basket, and doesn't distract from the bright froth of flowers that catch the light.

The eye is able to concentrate on the pansies and daisies, and then is slowly drawn across the rest of the group, sitting quietly, waiting.

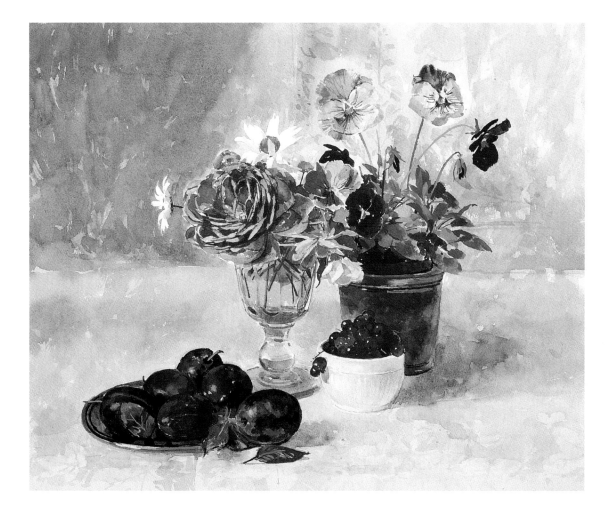

ROSES, PANSIES AND PLUMS
*Gouache, 13x17in
(33x43cm)*

It was a question of aesthetics that troubled my student mind, and the realization that the extroversion of Dutch painting was about to be balanced by the quiet introversion of the French. Tables teeming with fish, fruit and flowers bubbled noisily inside their frames, but the cup and saucer sat quietly and spoke volumes. It had more magic; a silent mystery that beckoned you over and invited you to enter in. I had discovered the contemplative rather than the exuberant.

There is so much unspoken power in the simplest objects and it is essential to have a sensitivity to this force and feel it, or there can be no response to this genre. You either have it or you don't. If you don't, it doesn't matter because your response will be directed towards other things that do speak to you. You cannot paint still life without it, however, and you can only ever paint the things you truly love, whether it is a cup and saucer or a jam jar of buttercups.

A magpie instinct to collect china and odd boxes, baskets and bits and pieces fed quite naturally the urge to paint them. This feeling crystallized after I read 'Introduction to Still Life' (1954) by Allan Gwynne-Jones on painting still life.

In it, he mentions the seventeenth-century Spanish painter Juan Van der Hamen y León and his wonderful assembly of baskets and dishes, sugared fruits, pastries and preserves, 'Still life with sweets and pottery' (1627). It is a large painting of objects on different levels. One jar of cherries 'glowed like rubies', he said. I wanted to paint jars of fruit that glowed like rubies, and began dredging bookshops for anything I could find on

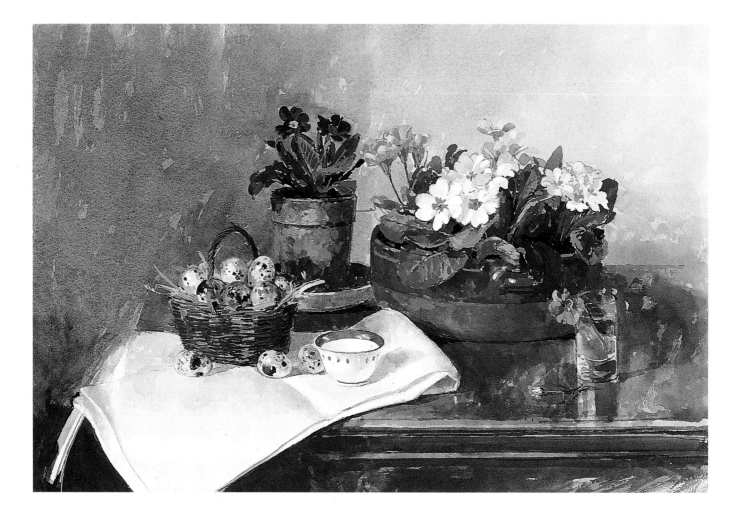

WINTER PRIMROSES IN A DISH
WITH QUAILS' EGGS
Gouache, 13x20in
(33x51cm)

still-life painting. Practically all the examples were oil paintings except for a few Italian and Victorian English watercolours.

Because there are not many still-life paintings even in oils, I found it worth looking in odd corners of famous pictures where still life appears as a secondary subject. In the Velazquez 'Christ in the House of Martha' in the National Gallery, there are fish and eggs on the plates and a pitcher at the back of the group. The colour is severely restricted and the tonal key low. The table-top in Caravaggio's 'Supper at Emmaus', also in the National, has a fine still life, in particular the basket of fruit perched precariously on the edge, slowly rotting; but the great treasure of this gallery is Chardin's painting of oysters and a silver goblet brimming with red wine.

The Louvre in Paris houses Baugin's 'Dessert and Wafers' and 'The Five Senses'; the Musée d'Orsay has a glorious collection of Cézanne still-life paintings and a few by Fantin-Latour. It can be a life's work just getting to see the originals, but once you begin to appreciate the beauty in still life, it can become a compelling search.

I persevered because I found that all I had learned from the study of oil painting could also be applied to gouache. The medium is incidental. Richness of colour, ambitious arrangement and robust handling are all equally relevant regardless of the medium.

In spite of my student introduction to Cézanne, I still admired his work profoundly. I have no difficulty in looking at his oil 'Apples and Oranges' – a table with a rich carpet thrown over it, a compote dish, a jug, and strewn oranges and apples – in the Musée

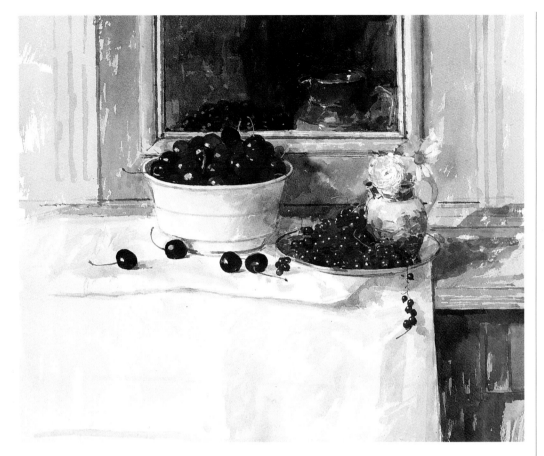

CHERRIES WITH REDCURRANTS
ON A DRESSER
*Gouache, 12x18in
(30.5x46cm)*

d'Orsay and seeing its equivalent in gouache. The important fact to appreciate here is that it is not the medium that matters: it is the painting itself, regardless of how it was done.

This particular painting strikes several chords with me. I think it is worth mentioning that some paintings will always immediately take the eye and others may not. It's worth trusting this instinctive response. Pass over those that have nothing to give you, and learn from those that call you. There are so many paintings in galleries, and the quiet practice of selection sifts the ones that are going to be of use from the ones that will not. You don't have to know why you like or dislike one painting rather than another. A gentle graze across the ones that appeal feeds the eye.

Browsing in books and looking at paintings came to follow the same pattern as collecting china from second-hand shops, and gradually it all began to come together. I realized that still life demands an intimate view and an intensity of vision; a humble attitude and total receptivity. Painting still life is like a one-sided conversation, where you sit and listen quietly and attentively to what the objects in front of you are saying.

The demands of this kind of work are at a much slower pace than most forms of painting, and tend to be contemplative. It has a calming effect. The model is not alive, and will not move, get dressed, go home for supper or disappear entirely as the light does across a landscape. It is there for as long as no one touches it.

However, still life painting is entirely to do with painting the truth, a quiet view of an actual world. It is pointless to invent a still life. It is a close observation of reality, a refreshing and actual look at things as they really are, not as they are imagined. It is about the quality and nature of inanimate objects, and one of the painter's aims should be to

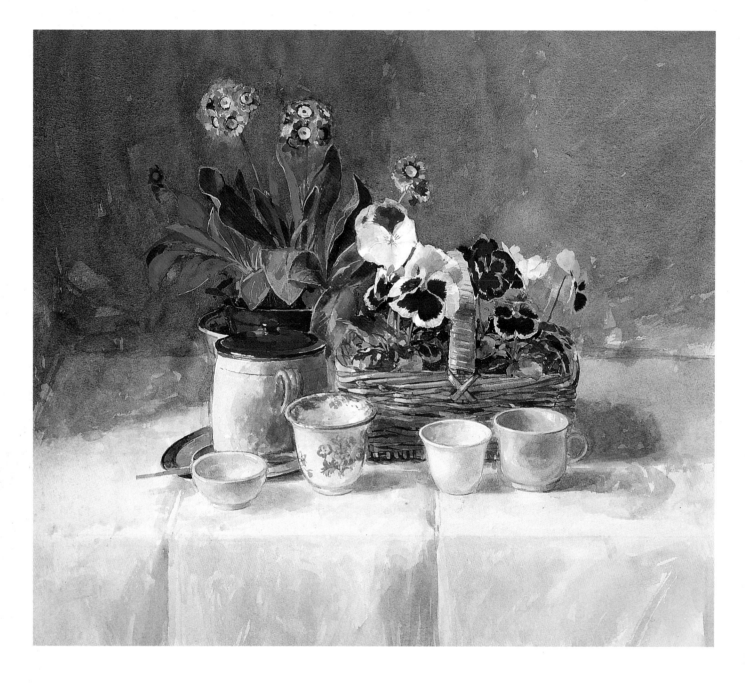

AURICULAS, PANSIES AND BOWLS
Gouache, 18x20in (46x51cm)

*Arranged as a triangular group, the pots form an emphatic
baseline and the flowers cascade along a hypotenuse. Baskets and
bowls, dishes and darkness make this a painting completed early in
the year in a wintry light.*

*Painted thinly, there is little that is opaque but much that is
richly saturated colour. A detail of the painting is shown opposite.*

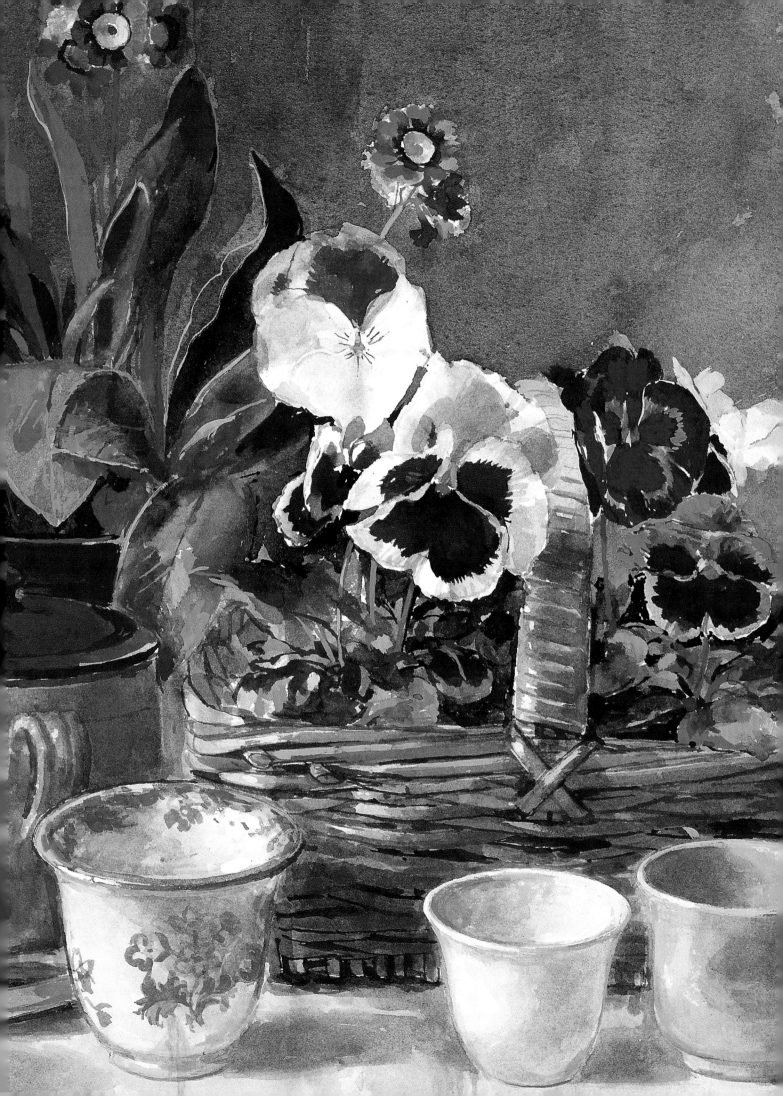

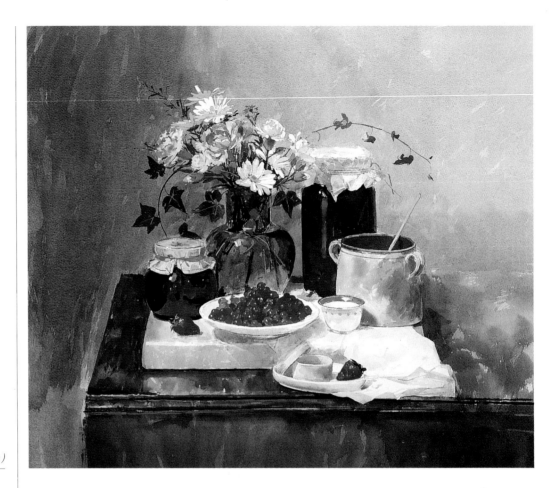

study and understand what makes glass appear transparent, china uniquely china and linen peculiarly linen, and not satin or velvet.

Contained within it is light, atmosphere, colour, form, depth, design and arrangement – but above all, there should be an intensely personal feeling of delight in everyday objects within their setting.

The subject matter sets the feeling of the painting, and can range from the charm of a simple dish of fruit to the brutality and menace of the flayed ox of Rembrandt, or the ray-fish of Chardin. Colour and tone can effect the atmosphere and response. Violent swathes of colour can unnerve, as in a Matthew Smith, or calm and even amuse, as in Sir William Nicholson's almost monochromatic 'Miss Jekyll's Gardening Boots' (1920) in the Tate Gallery.

Still life is not necessarily a woman's preserve. However, my view of still life must be coloured by my experience as a woman, which is in the main a domestic one. The still life is very much an immediate part of life. It feels as if it could only exist in the home; as a personal extension of everyday life. For me it is very much a part of my life. Even transporting a selection of bowls and cups to a village hall to try to explain things about grouping or arranging to the local art society doesn't seem to work. Like some fine wines, still life doesn't travel well. It is suddenly out of context.

The practical business of setting up a group and getting on with it is something that develops gradually. I found it moved from the small and tentative to the larger, more ambitious scale over many years. However, the beginnings need to be simple so that bit by bit they build to more complicated arrangements.

There are many ways of looking for subject matter, but broadly speaking they fall into two categories: the classic 'arranged' still life and the more casual 'found' still life that is sitting there, a part of the normal business of living.

A 'found' still life is exactly that; something unexpected but beautiful. One of Chardin's most magnificent paintings is a flat basket piled high with a pyramid of wild forest strawberries on a bed of leaves, a glass of water glowing with the reflected light from a white dianthus to the left of the basket, the whole placed on a shelf and giving the feeling that the painter had glanced at it from the corner of his eye, and found it magical. The air around it shimmers with the warmth of colour from the fruit.

There is, however, enormous frustration in seeing a perfect still life sitting quietly somewhere and being unable to do anything about it. Recently I visited the cave in Patmos where St John wrote the Book of Revelation. It is a shrine and enclosed now within a church, but on the outer wall was an alcove beside the window and sitting on its ledge was a magnificent basket, full of bread and a cloth. Above it was a fragile hanging lamp or censer on a nail, unlit, but waiting. There was a severe almost fifteenth-century simplicity to the arrangement, and a limitation of colour that made the whole monumental and eternal. I managed a rapid drawing of it merely to remind myself of the occasion but I would much rather have spent time painting it. It had for me more of the rigour and asceticism of the Holy place than any other single artefact there. So still life can hold powerful evocations of time and place. It is not merely a collection of things.

An 'arranged' still life acknowledges valuable lessons learned from encounters similar to the basket of bread in the cave of St John. The 'found' or 'seen' grouping feeds the more formal re-creation in the studio. Setting up a group needs care, and consideration must be given to the emphasis intended to be placed on each object.

Whatever you decide to paint, the objects should all be able to live together amicably. There should be a logic or natural sense to it. One of the most important questions to be answered at the very beginning is 'What am I interested in?' 'What is it that delights my

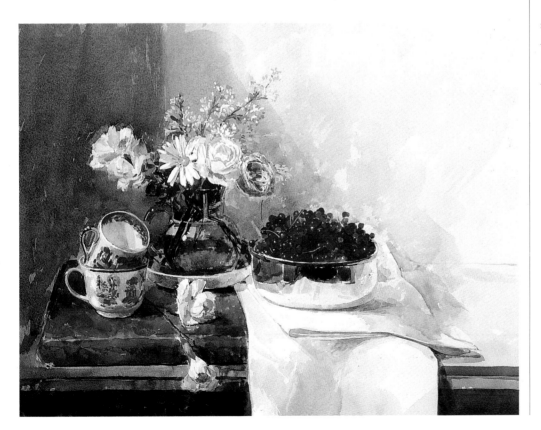

SILVER DISH OF REDCURRANTS
AND SUMMER FLOWERS
*Gouache, 13x20in
(33x51cm)*

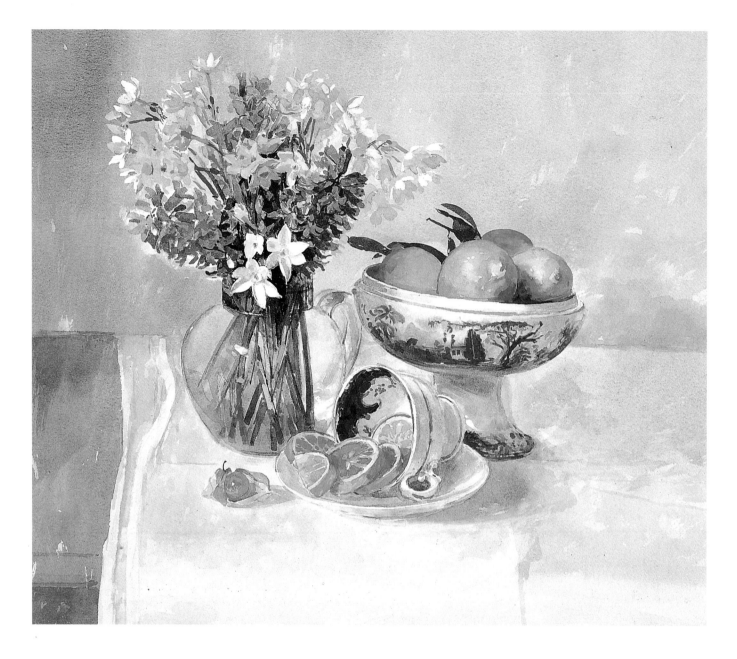

Above
DISH OF LEMONS AND SPRING FLOWERS
Gouache, 16x18in (40.5x46cm)

Opposite
YELLOW ROSE AND LEMONS
Gouache, 9x12in (23x30.5cm)

Another attempt at balancing the colour opposites of yellow and blue; a magical colour combination. Blue and white china and lemons counterpoint with their colour mix of green. Great precision is needed in the drawing of the jar of spring flowers. Careful drawing and judgement of tones is also necessary in the white flower heads of narcissus. There is a tendency to make shadows on white forms too dark. They are much paler than you think.

Painted, for a change, on a sheet of coloured Ingres paper rather than on a white ground, this small picture threw up a whole range of difficulties. It prompted a much greater use of opaque colour to combat the colour of the paper. Compromises had to be accepted in the various colours that the yellow made on it in the roses.

However, a coloured ground does help to pitch the middle tones of the painting and makes it much easier to work lighter and, conversely, darker in tone. The ground helps to unify the colours and makes for a richer overall look to the painting.

eye?' Every trip around the countryside, or, more excitingly, abroad, is a plundering one. Trawling round junk shops at home or any shop abroad is finding treasure trove. I have brought back biscuits from Madrid, pastries from Venice, bread from Paris and brass bowls from Delhi – and baskets from everywhere.

Sometimes it is suggested that a preliminary drawing will help at this stage. I rarely make preliminary drawings or sketches of a group. Preliminary drawings can help to focus the attention and point up any need to rearrange or rethink things. It does save a great deal of time to do this early on in the process rather than investing much time and labour on a still life and finding, all too late, that it is not going to work.

A greater confidence and more familiarity with the subject makes preliminary drawings unnecessary, even undesirable. Valuable energy can be wasted on a drawing which would be better spent directly on the painting. An early separate sketch can defuse the head of steam that is vital for a spirited attack on the actual work.

The drawing that might be done in pencil can be made equally successfully in a pale blue line with a brush as the first stage of a painting. Small mistakes can be corrected, large ones washed out completely but gently. When the paper is quite dry again, it's possible to have another stab at it.

This is a far better method of procedure: all the pain of sorting it out is contained within the work and enriches it. A separate first drawing in an isolated, exploratory way means a change of medium and an ironing-out of all those nervous indecisions that give the finished painting life. By going straight in with a brush the effort is concentrated in one place, and adds to the total sum of observation. The nervous energy that is the difference between life and death in a painting has not been dissipated.

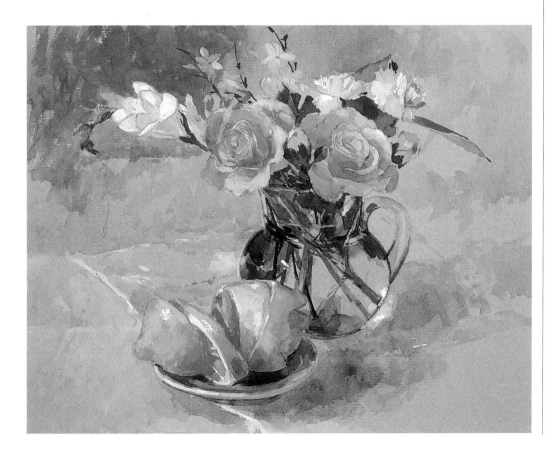

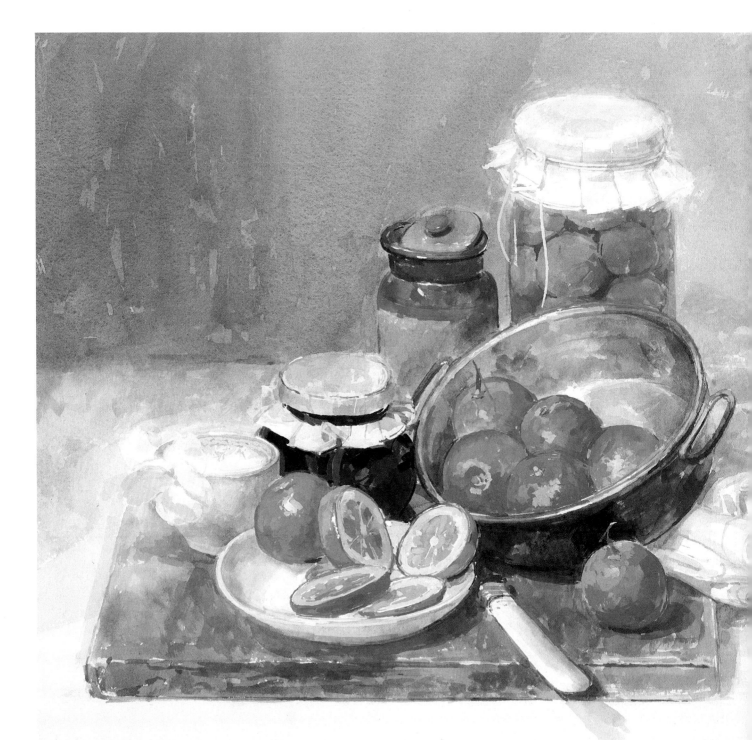

SEVILLES IN A PEWTER DISH AND MARMALADE
Gouache, 13x19in
(33x48.5cm)

CLEMENTINES, APRICOTS AND PRESERVES
Gouache, 10x13in
(25.5x33cm)

Circular shapes are comforting. The various ellipses link the circles of oranges, jars and apricots. The colour range is limited to oranges, browns and neutral greys and the rich, dark-toned background throws the group into a dramatic prominence. It is simple in arrangement, yet varied enough in shape, texture and incident to sustain a quietly concentrated study.

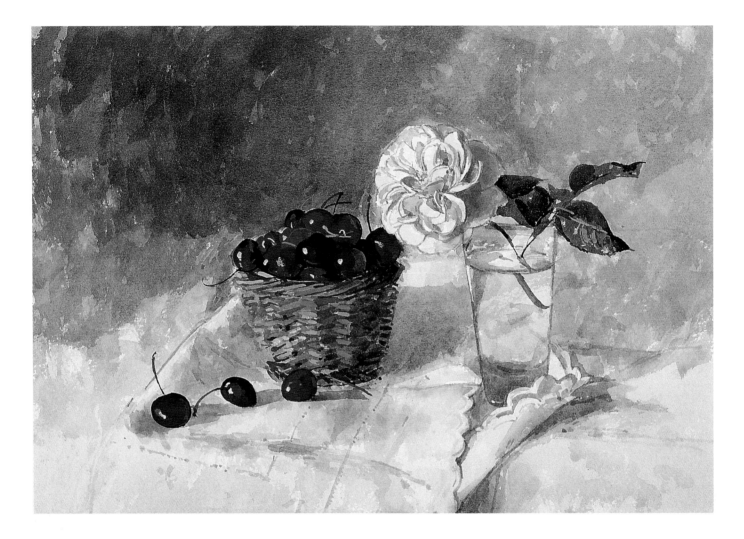

SMALL BASKET OF CHERRIES
AND ROSE FANTIN-LATOUR
Gouache, 8¹/₂ x 12 in
(21.5 x 30.5 cm)

One of the most extraordinary aspects of still life is that it is a form of painting completely controlled by the artist. I decide what to paint, how and where and under what kind of light it is to be painted. I am in charge. The degree of control and decision is total, which makes it easier and at the same time much more difficult. (When there are so few limitations, I still wonder at the state of the college still life cupboard and put this down to indifference. It was the only cupboard I have ever seen that really did have skeletons rattling about in it!)

With total control and no limits at all, it is helpful to set one's own. A group of objects bound together with a common theme is a good start. With gouache specifically in mind, I set up the fairly complex still-life arrangement shown in *Sevilles in a Pewter Dish and Marmalade* (page 78). This is one of a long line on a theme. I have painted other 'marmalade' pictures in oils and gouache, each developing from the last. A group of like-minded objects gives a more coherent theme to a painting and here the pewter dish of Seville oranges, the preserved mandarins in a jar, the tawny brown globular jar of marmalade and the cut oranges on a saucer echo and repeat the colour and theme throughout the composition. A limited palette of colours ensures overall harmony, and cooler greens and greys in the background serve to sharpen the fierce oranges. The browns act as the glue which cements and binds the whole rather classical arrangement together to a pleasing finish.

The individual parts of this painting are all much-loved objects. The pewter dish belongs to my mother and is my favourite bowl. The crisp blue/grey lights in its interior are flecked with unexpected purples when filled with oranges. Its outside is a much darker, non-reflecting hue which makes it so interesting to paint. The jars are old friends, culled from Fortnum and Mason while visiting the Royal Academy Summer Exhibitions. The oranges in syrup come from one of the epicurean delicatessens of the Cotswolds.

Circles, spheres and ellipses range through the group and are held together by the safe rectangle of the chopping board. The placement of one object in front of another is carefully considered; the intervals of colour carefully spaced. There must be no uninterrupted surface of one colour or texture that goes on for too long. There should be variety throughout and constant interest in varying degrees of intensity.

Approached exactly as one would a watercolour, the particular quality of gouache gives a greater weight, solidity and saturation of colour to the oranges, for example, than would be possible in 'pure' watercolour. The highlights on the rim of the pewter dish are undiluted permanent white. I can have more than one stab at finding the angled ellipse of this dish in the initial drawing-in with a very diluted ultramarine blue. It doesn't matter if I get it wrong: I have the freedom to get it right. When it is as I want it to be, should I have lost the lightest tone for the rim, it is the easiest thing simply to draw it in with opaque paint. You have your cake and you can eat it, too.

SUMMER FLOWERS IN A CREAM
AND ENAMEL MUG AND COBNUTS
*Gouache, 10x13in
(25.5x33cm)*

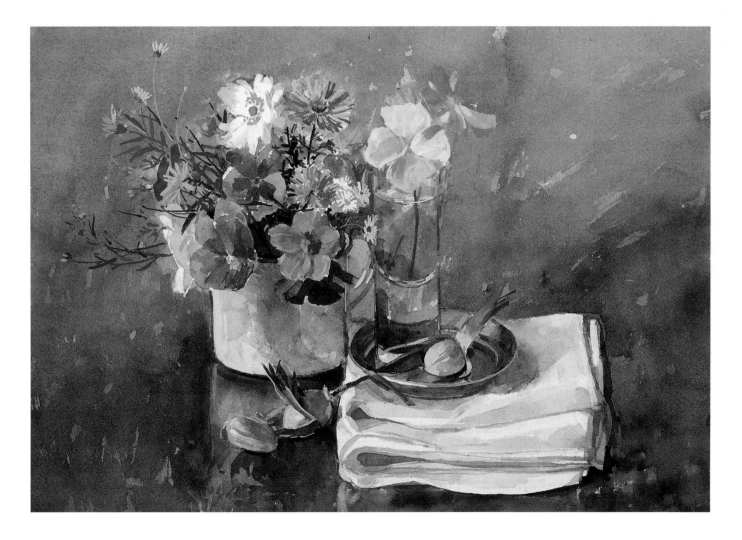

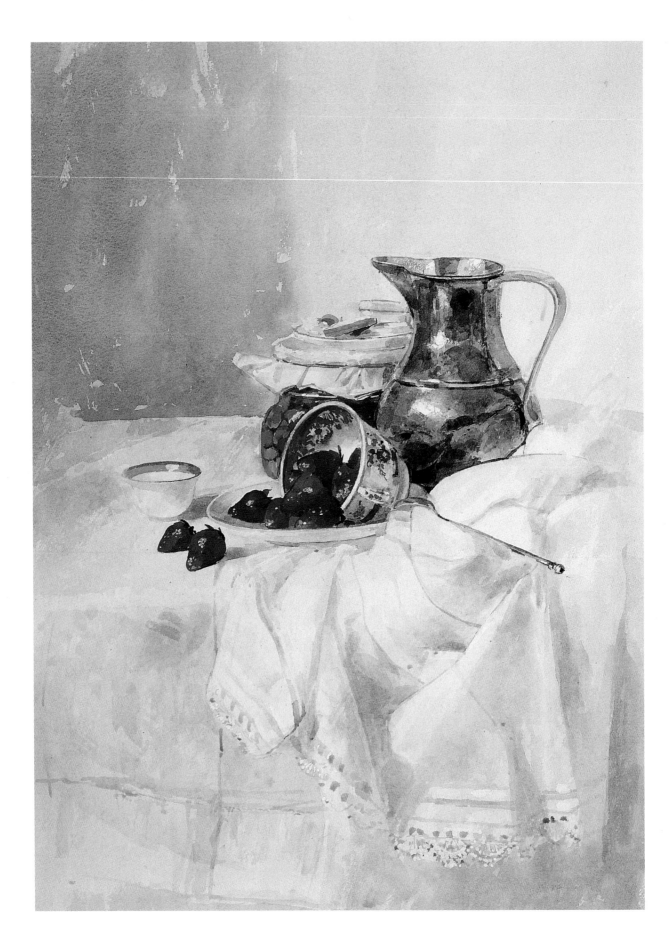

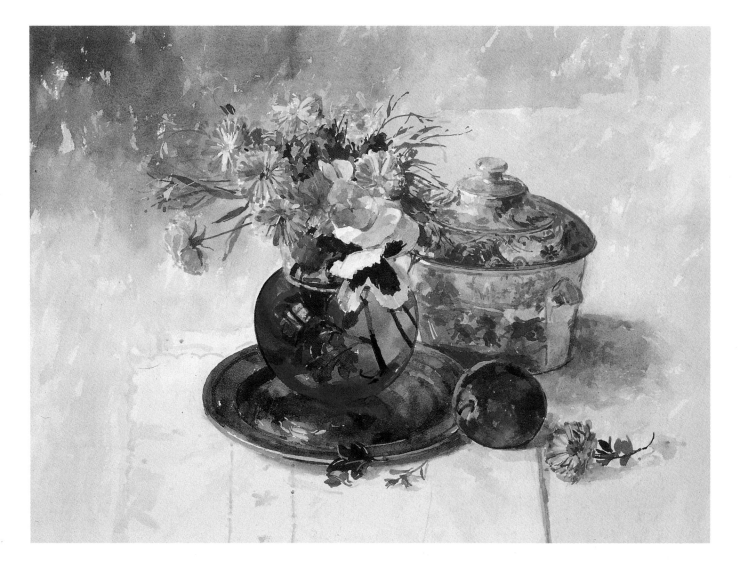

BLUE GLASS OF FLOWERS
AND SPODE BUTTER DISH
Gouache, 9x13¹/₂in
(24x33cm)

One of the great benefits of gouache is that you can start with the background and work forward. The first washes of colour can be as pale as you need them to be. They can be built up in tone as the work progresses. Areas can be left for lighter objects and you can 'feel' your way around things early on in the initial drawing-in. Should mistakes be made, or parts overpainted that you would rather have left, it is still possible to retrieve the work by drawing on top with opaque gouache. Nothing is lost, and the materials give you the opportunity to push the work further and further.

It is always a mistake, I feel, to keep any area of a painting so tightly controlled that one slip of the brush could spell disaster. It should all breathe naturally and have a life of its own that allows for areas of loose brush work, second thoughts, adjustments and experimental colour washes that accumulate to enrich the whole.

The inclusion of fruit or flowers in still life gives an added quality to a group. I find it difficult to resist a rose in summer, or an orange in the miserable months of winter, to lift and light a painting. For this reason, sometimes flower paintings merge into still life and a still life almost becomes a flower painting. The study of both go hand in hand.

Opposite
PEWTER JUG AND CUP OF
STRAWBERRIES
Gouache,18x13¹/₂in
(46x34.5cm)

Chapter Four

FLOWERS

If it is difficult tracking down still-life paintings to look at and learn from in order to progress, examples of flower paintings can prove equally elusive. Admittedly there are flower paintings and flower paintings, and the subject is a thicket of prejudices and preconceived notions. Mention flower painting to almost anyone and the eyes glaze over, the stereotypes materialize and the critical faculties are locked on 'pause'. This is understandable: something strange has happened to the acceptability of flower painting in establishment circles. Since the end of the last century it has suffered relegation to the attic end of received artistic priorities, the province, mainly, of the adaptable and open-minded amateur.

The great Victorian pastime of painting delicate watercolours of flowers to fill the long empty hours between lunch and dinner has insidiously affected attitudes. It now has overtones of old ladies whose jar of paint-water never gets murky and whose sable paintbrush never has more than nine hairs.

BASKET OF CHERRIES
AND SUMMER ROSES
Gouache, 13x15in
(33x38cm)

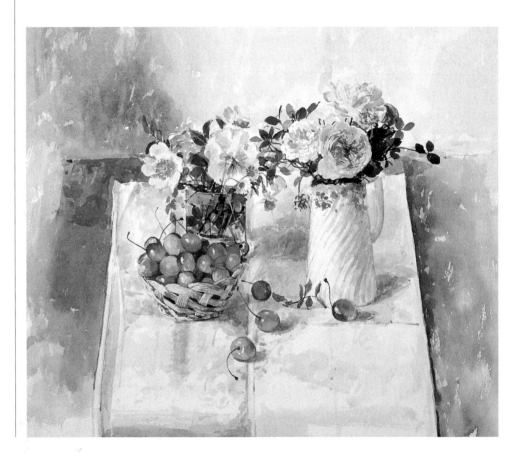

Opposite
ROSE AND PETITE FLEUR CHINA
(detail)
Actual size

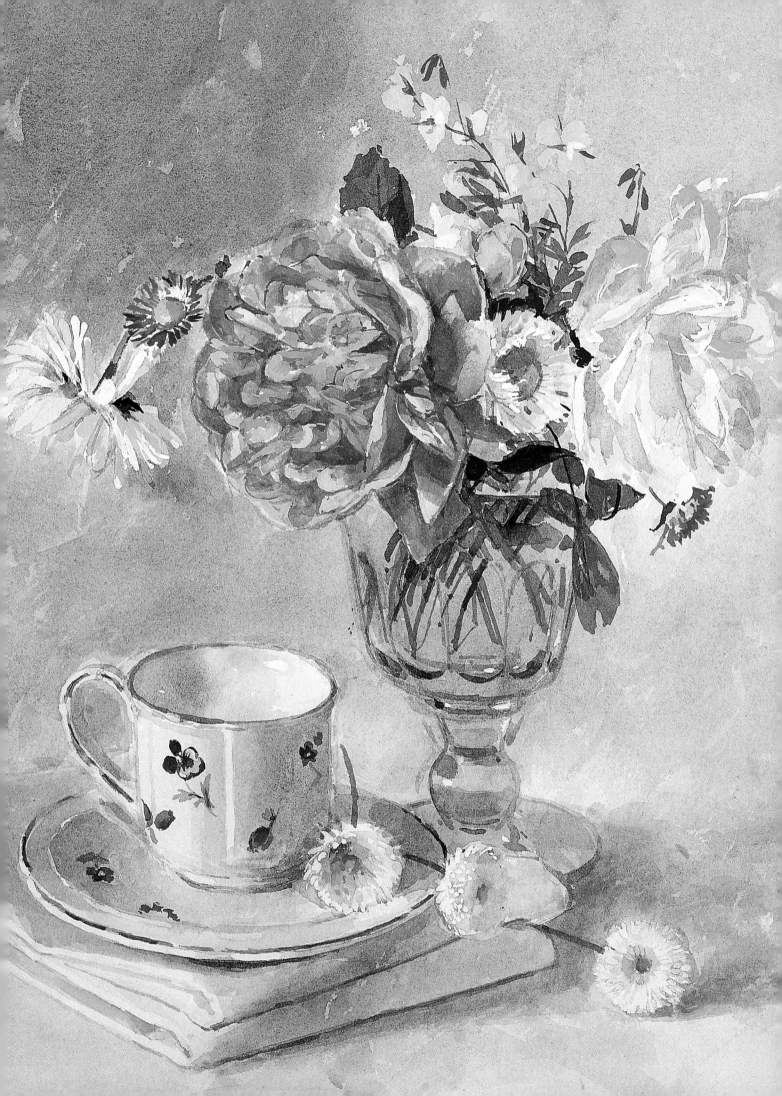

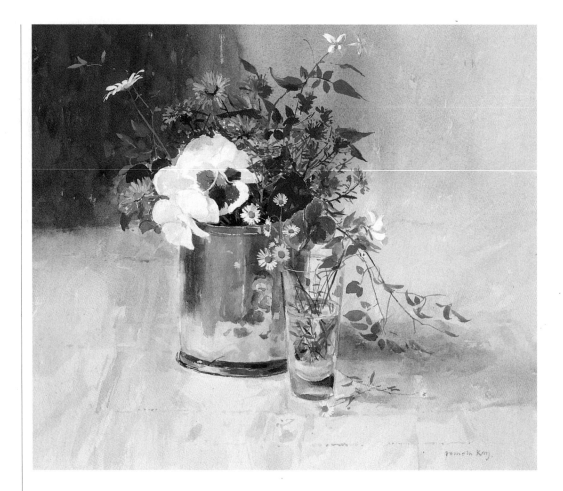

COPPER POT OF SUMMER FLOWERS AND A GLASS
Gouache, 13x16in (33x40.5cm)

Many brought up in the repressive tradition of 'fine art' education would frown upon painting copper and consider it in poor taste, and slightly 'flash'. I find this attitude quaint and blinkered. Copper is wonderful to paint.

Perhaps because I know that this attitude prevails I enjoy painting copper all the more, reminding myself that Chardin also revelled in it. The colours are sensational and surprising. Orange and flame red help to make the warm pinky-orange that is the first colour to strike the eye. There is purple, alizarin crimson and sometimes burnt umber in there as well.

The range of tones and colours is wonderful and changes with whatever is reflecting in it at the time. Glass is equally challenging and satisfying to paint.

In this painting, the sharp jump in tone from the background blue to the white pansy sets a dramatic counterchange that peaks, then gently calms as it progresses across to the right-hand side of the picture, ending with the gliding sweep of trailing clematis leaves.

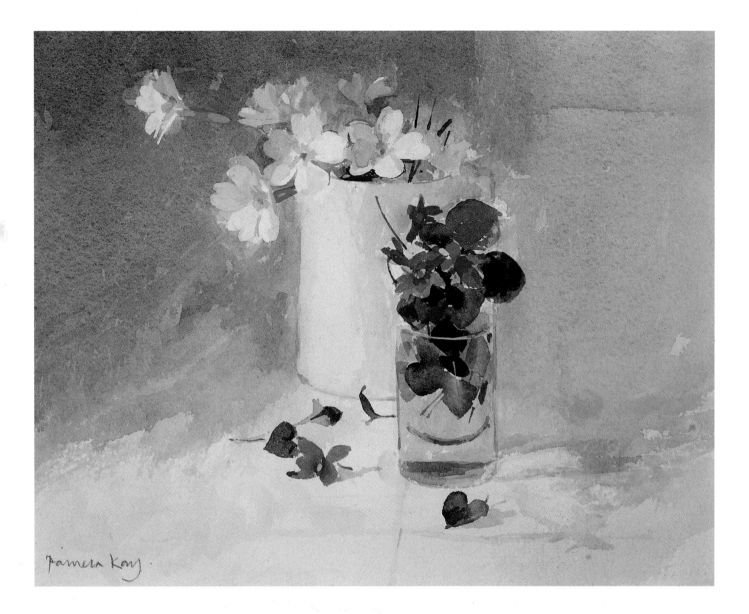

PRIMROSES AND VIOLETS
Gouache, 11x9in (28x23cm)

Pale and interesting, primroses in early spring can look as though they are blinking and gasping in unaccustomed spring light. They must be painted with fragility written all over them.

Palest washes of cool grey are used to draw in their container and the colour of an amorphous background. A contrasting purple violet with rich dark olive leaves gives a strength to what would otherwise be too delicate a painting to sustain. It needs a strong note of colour to give it some force which will provide a contrast.

Primroses only look delicate if there is a bruiser of some sort to counter this quality. Shy violets do it superbly with their colour. This stops things from getting too bland and boring – very important when painting.

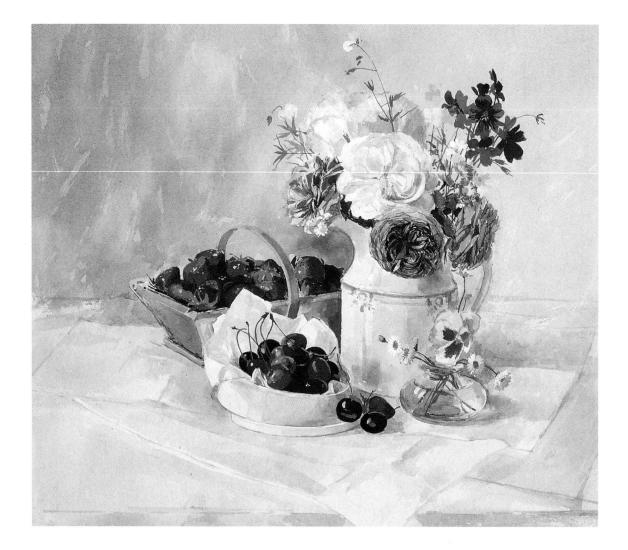

JUG OF ROSES, STRAWBERRIES AND CHERRIES
Gouache, 17x15in (43x38cm)

WOODLAND FLOWERS IN A GLASS
Gouache, 18x12in (46x30.5cm)

A pyramid of reds, moving from the orange red to the purple red, is set in a neutral toned collection of jugs, bowls and dishes. The pale grey background lays emphasis on the most complex parts of fruit and flower. Anything too elaborate in the china would make for a congested appearance.

It is very important that the selection of accompanying still life is every bit as careful as the choice of flowers and the arrangement of the group. Complex parts need to be balanced by sober neutral areas.

The eye travels in a gentle spiral up from the fruit at the bottom of the group, through the dishes of strawberries, up to the swag of roses, finishing with the little purple flower at the top. It runs back down again to the pansy in the glass jar. This easy trip for the eye gives a calmness to the atmosphere of the painting.

This is a lively piece of brushwork. There isn't a still moment anywhere on the paper. It has a nervousness that reflects the fragile quality of woodland primroses, wild bluebells, campion and early 'wedding-cake' – known as 'snow-in-summer'.

All the flowers are crammed into a heavy-bottomed, rather sober whisky tumbler and admired for their transient presence. All is laid-in with soft washes of gouache, watercolour style. A rich layering of stalks and leaves in the middle of the group (without regard to what is in front of them) means it is necessary for a final 'drawing-in' of the paler flower-heads in opaque pigment.

The lightest parts of the white flowers at the top are also drawn-in with the brush using permanent white gouache.

So much flower painting of the nineteenth century in England teeters on the edge of sentimentality, and a great deal of it wallows unashamedly in it. An approach that is too sweet may be pretty but tells us nothing new. It descends to the decorative which is fine if all you want is a painting to match the wallpaper. It will not exercise the intellect nor delight the eye. In fact, after a very short time, it becomes invisible. It lacks the vital ingredient: that which lifts it from the banal, enlightens the eye and gladdens the heart.

This ingredient might also be described as a gentle recklessness, a cheekiness or bravura, indeed, a personal view. It is something that stops you and makes you notice it. An unassuming jug of garden flowers tenderly seen, or Degas' bucket of chrysanthemums with a slightly nervous girl edging off the right-hand side of the canvas, can arrest and intrigue.

It is a question of style. We were staying overnight in a hotel in Amman before journeying on to Petra. A blonde lady in a full-length black fur coat entered the reception area, walked slowly over to the grand piano, paused, then ostentatiously peeled off her coat and laid it fur side up across the top of the piano. She was the resident pianist and had come for her evening gig, but did so with great style. It was a sweltering ninety-eight degrees outside, but she was making a statement. To me it was deliciously bizarre, incongruous and fascinating to watch. This is what should happen in a painting. A slight edge of unexpectedness.

There is a nervousness about the fragility of flowers and it should be there in the painting. A delicacy of touch that appreciates a fragile stem, yet drawing it with uncompromising certainty, as if it were high-tensile steel.

As with still life, a simplicity of approach is invariably the most effective. A rose in a glass, a jam jar of daisies or buttercups, can evoke an entire summer. An unambitious,

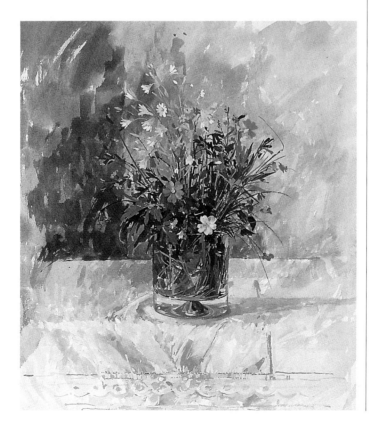

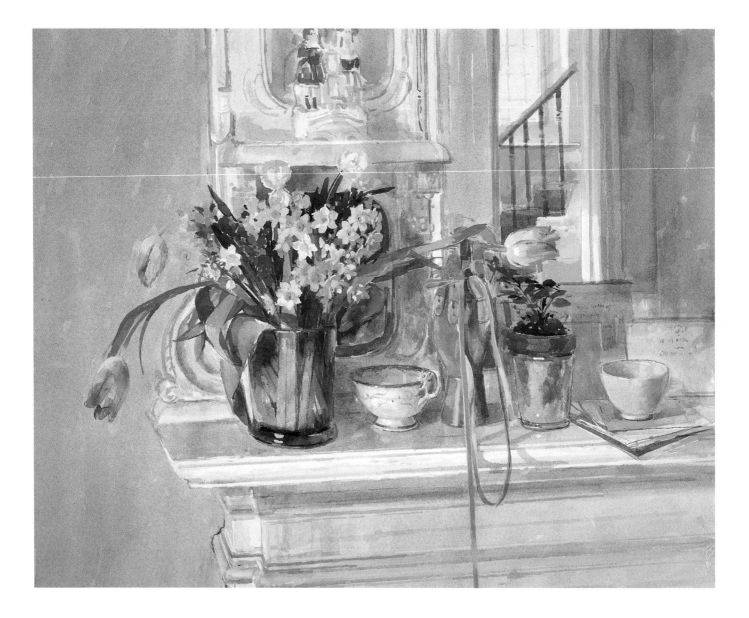

quite humble collection of simple forms, viewed in the right spirit, can be extraordinarily beautiful. It takes very little to make a delightful painting.

More contrived arrangements in the 'flower arranger's' manner can be too stiff and formal. Stunning though a pyramid of stately architectural peonies and lilies may look in front of an altar, or on the sideboard of a stately home, they do not make happy paintings. They are sufficient in themselves, an enrichment of their setting, but they do not transpose well to another medium.

You do not have to know the rules of three-point turns that are used to construct the arrangement of such an edifice of flowers in order to produce good paintings. A jug crammed with corn poppies and wild roses will suffice. It is a different aesthetic. Again, it is the simple rather than the grand; the retiring rather than the ostentatious.

This is not to say that flower painting cannot be exuberant. Although it is wise to start with small beginnings, there is nothing more challenging than a complex collection of flowers to give another dimension and to stretch the abilities. There are no rules, only personal preferences and guidelines.

One of Renoir's early paintings (in oil, I'm afraid) is a jar of summer flowers – lilac, peonies, wallflowers and roses, clearly painted out of doors, in a full bright light, the like of which we can only dream about in England. It rolls, convoluted and indiscreet in its sumptuous forms, all around the large canvas, in a great arc of flowers firmly held in a blue and white ginger jar. The light on them and the touches of close-toned paint flicker across the surface. Underneath, the drawing is as hard as reinforced concrete and never misses its mark. It is a large, loosely complicated group, and is painted broadly.

I think it is this feeling of generous frenzy that is the benchmark for large flower paintings, in precise contrast to the more calmly stated small paintings that are domestic and intimate in nature. The former at full blast and evocative, the latter a quiet reminder.

A small bunch of flowers in a jug or teacup, brought into the house and placed on a favourite shelf, table or ledge, can be sufficient. Equally, a corner of a table in the studio, perhaps against the wall, can provide a sheltered area of concentration for a glass of flowers. They do not need too much arranging – more a 'settling-in'.

It helps to consider the size of flower-heads in the collection you put together. A regular sprinkling of dahlias, for example, can look like tight tennis balls dotted insistently amongst the rest. It is unsympathetic. Flowers are at their best when they are wayward and in character. Floppy daisies sit well with slightly more erect roses. Grasses fall about and make a delicate tracery behind patterns of poppy-heads or marguerites. Tall spikes of gladioli or irises can feel uncomfortable and aggressive. There is an unconscious message behind the choice, just as there used to be a symbolic one in medieval times.

There is an overwhelming rush of flowers in June and July. All the different roses flower simultaneously and an abundance of blooms means a race against time to get it all down on paper or canvas. Many painters shy away from these annual delights, muttering 'Monet's done it'. It is profoundly difficult to paint sunflowers when Van Gogh has done the definitive version, but Monet painted them as well, and they were completely his.

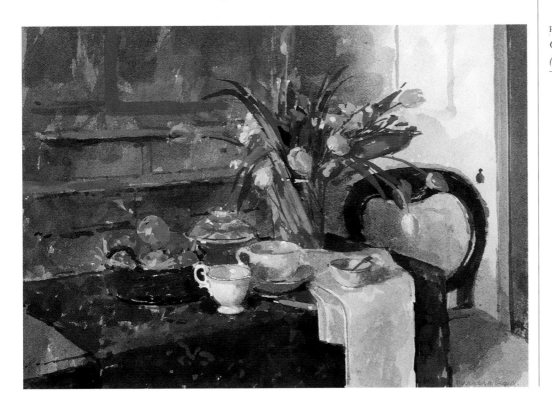

FLOWERS IN THE STUDIO
Gouache, 7 x10in
(18x25.5cm)

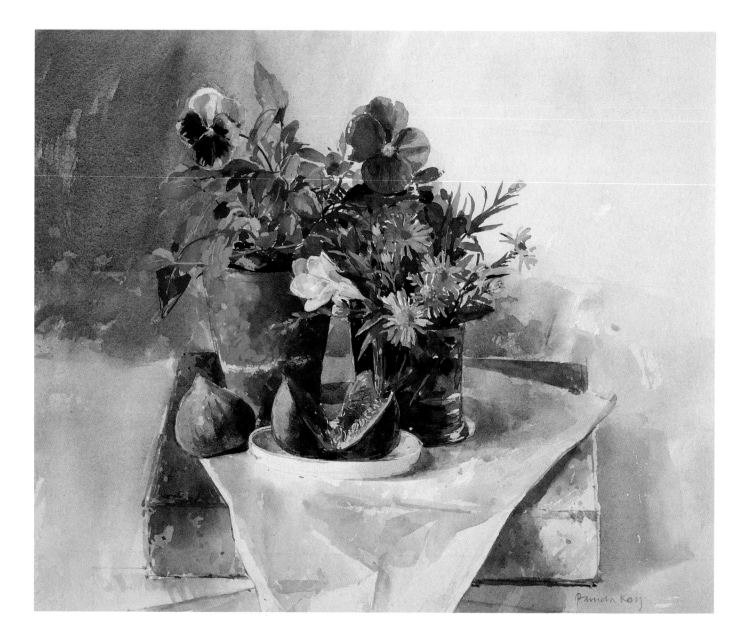

FIGS, PANSIES AND ASTERS
Gouache, 12x17in (30.5x43cm)

This is a quiet composition of like-minded colours. It is simply a flower pot or two of pansies, and a glass of Michaelmas daisies – with a yellow freesia to give bite to the colour and a centre to the arrangement.

A small china dish contains a black Turkey fig, split to show its ravishingly complex interior. The whole group is set on a concrete paving slab on which is placed a sheet of white tissue paper.

It is 'drawn' with thin colour, each additional touch of the brush adding to the accumulated information. Where the tones have become too rich or heavy, a lighter opaque patch of colour is used to 'redraw'. It is, as with all paintings, essentially a form of drawing, using colour.

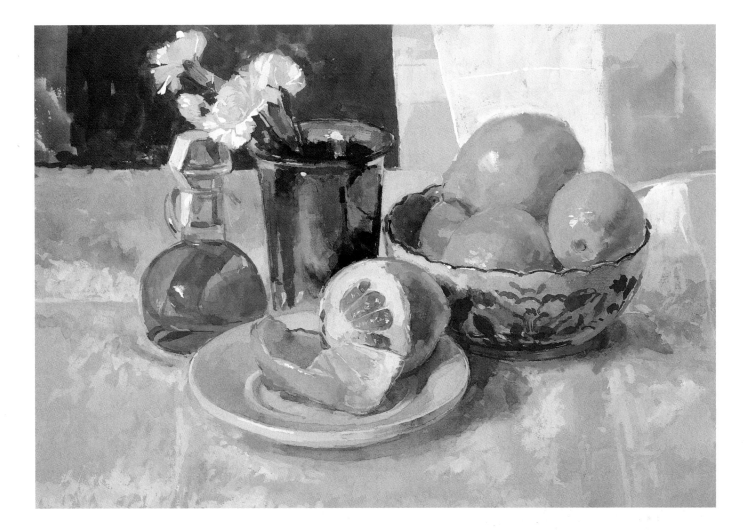

DISH OF LEMONS WITH A PEWTER MUG
Gouache, 9x13in (23x33cm)

This small painting was executed on a mid-toned Ingres or Canson paper, the colour of a pale brown paper bag. There was a board ready stretched with this paper and handy, so I used it, rather than a white surface. It is really quite a European group of objects: the pewter mug came from Reims, the saucer, thick and chunky, from Venice and the lemons doubtless from Sicily.

The medium is used much more opaquely here, as there is quite a lot of white in all its various tones. Having toned paper immediately sets a low key for the whole painting, making it easier to move higher or lower in tone across the group. The colour is kept to a limited palette and the brushwork lively. This avoids large areas of colour becoming flat and uninteresting.

An overall low-key tone to a painting gives a fine opportunity to enrich the colour and make the lightest tones really sing. A compact grouping that is almost circular in ground plan provides a comforting, sociable composition that revolves nicely.

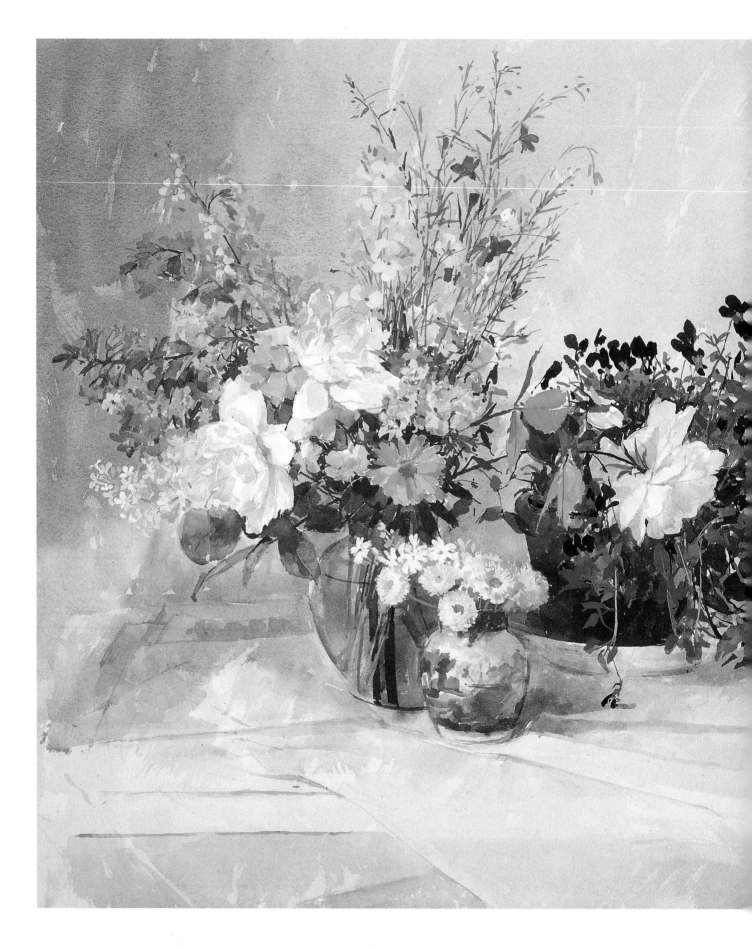

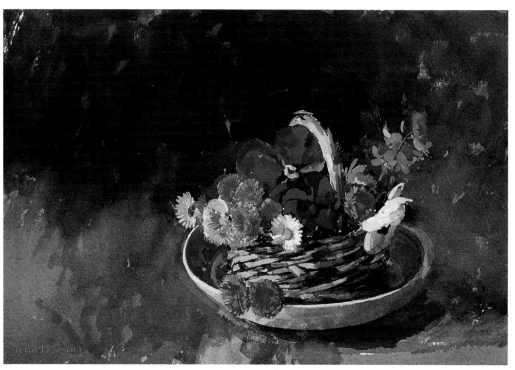

SMALL BASKET OF PANSIES AND BELLIS DAISIES
Gouache, 7x9¹/₂in (18x24cm)

Another example of the simple approach to compare with Small Glass of Roses and Violas
*(page 102). It is one isolated motif but this time on a very much darker ground. The strengths of the
tones and shapes in* Roses and Violas *make a pale background ideal in this small painting. The
darker tones serve to define and emphasize the light on the small bellis daisies and pansies.*

*A richly blue Victorian saucer complements the dark blue pansy. The crisp light tones of the white
daisies and pansy lift the richness of the colour. The light catching the edge of the saucer helps to contain
all the agitation of colour and form that is the focus of attention.*

*This may have worked just as well on a pale ground, but it would not have had the same
dramatic impact.*

Left
TABLE OF SUMMER FLOWERS
Gouache, 18¹/₂x22in (47x56cm)

*An ambitious group which, it has to be said, takes some speed and concentration to accomplish. The
flowers wilt and drop or twist and turn and they have to be caught before the progressive collapse that
will inevitably overtake them. There is a twitter of texture and colour across the surface. It is
fascinating to move from very subtle colours and tones on the left side – which reads against a slightly
darker-toned ground – to the stark counterchange of the white rose against the dark green foliage of
the violas.*

*Surprise and variety must hold the interest of the eye. If you approach this kind of group timidly,
your painting will be a pale imitation or a browbeaten gasp for air. You have to attack it with an
unflagging determination and energy.*

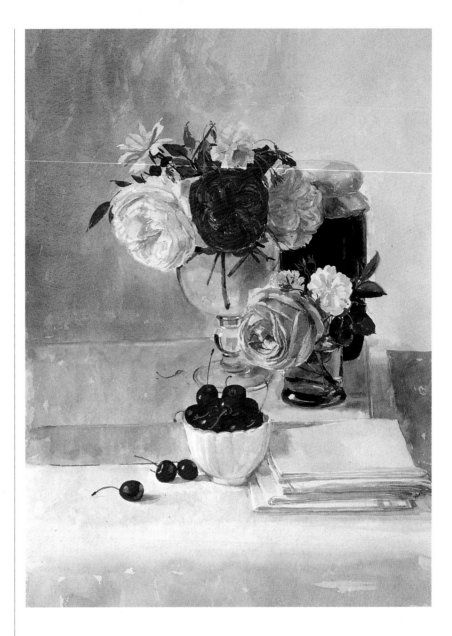

TWO GLASSES OF OLD-FASHIONED ROSES AND BOWL OF CHERRIES
Gouache, 13x19in (33x48.5cm)

*Pale pink roses can get lost if set against too pale a background.
They need a little drama – something to arrest the eye. In this
painting an emphatic dark red centifolia rose is painted mainly in
alizarin crimson and mixes with spectrum violet. The same mixes
with additions of jet black give the darkest tones of the jar of
preserves on the right-hand side of the painting. This makes a
calming vertical of rich, dark tone among the bubbling
convolutions of the roses. An echo of the same colour and shape is
found in the bowl of cherries. The colours are severely restricted.
All the reds are held together with warm and cool neutral colours
and simple forms. A detail of the painting is shown opposite.*

Having the audacity to put your own stamp on much-painted subjects is the only way to see flowers in a fresh light.

The medium of gouache is perfect to encompass these varied approaches. Painting flowers in gouache can produce a particularly powerful effect. It is possible to work in transparent washes only, directly with a brush, building up the strength of tones to a rich saturation of colour which has immediacy and concentration. This can result in a careful, intensely observed drawing in colour washes.

Dark tones are best kept richly thin and transparent as long as possible for the greatest colour value. An opaque dark tone has a finality that makes it harder to work into. Opaque touches should be the final ones. Flower-heads, too, are best kept as transparent washes, and the 'drawing-in' transparent for as long as possible. It may be necessary to use opaque mixes of colour finally to define the drawing more firmly. Unquestionably it is the richness of the colour – similar to that of oils – that I aim to transpose to gouache.

The texture and 'butteryness' that is unique to oil paints cannot be characteristic of gouache; nevertheless, a crisp delineation of a deep blue or purple pansy can achieve a velvety solidity similar to oils. It can sit in its own calm and considered atmosphere, surrounded by saturated colour.

A sound working knowledge of the medium followed by constant practice develops the confidence needed to launch into more ambitious work. From a purely technical point of view, it is not essential that a flower painting should be pernickety and precise. With the freedom that gouache gives, it is possible to lay-in a very broad base of underpainting and build up successive touches of colours to achieve a rich fusion of colour and texture across a massed group or, on a smaller scale, inside the complex heart of a centifolia rose.

This approach is much closer to that used when beginning an oil painting, with the same room to manoeuvre. It gives many more choices, and a chance to think on the hoof. Nothing has to be pre-planned, as with pure watercolour. You have everything to play for and can change your mind almost at will. It is a delightful freedom.

CUP AND SAUCER OF PANSIES
AND DAMSONS
Gouache, 9x12in
(23x30.5cm)

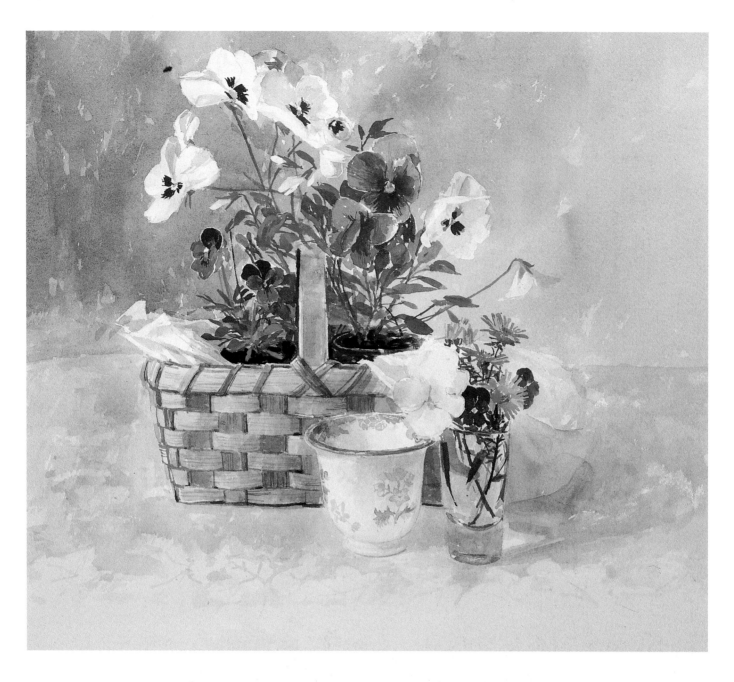

SHAKER JAM BASKET OF VIOLAS AND PANSIES
Gouache, 13x16in (33x40.5cm)

The theme of flowers in baskets is age old and can be seen in fine mosaic floors on the Greek islands, and in Naples museum, rescued from Pompeii. This small Shaker basket is intended to hold two pots of home-made jam, but does equally good service for two pots of pansies.

The colours of the flowers are picked up again in the delicate blue and white porcelain tea-bowl in the foreground.

Careful planning in the early stages can allow space for the heads of the pansies to sit comfortably on the background, which is not one flat wash by any means. I drew the flowers in lightly in pale ultramarine blue with a brush, then laid down a wash across the background. This varied in tone from the dark left-hand side to a fading off towards the right.

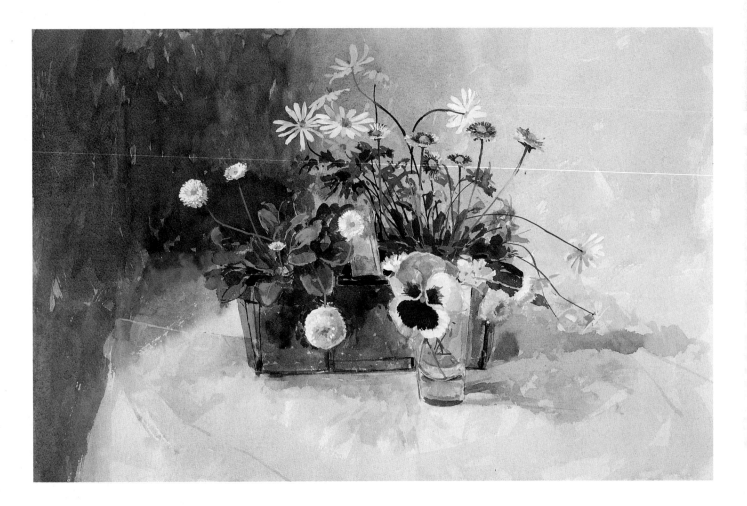

WOOD ANEMONES AND BELLIS DAISIES IN A BASKET
Gouache, 13x18in (33x46cm)

*A limited palette of colours and a simplicity of subject can
concentrate the mind on sharper drawing. In a sense this painting
is all about drawing with the brush; not necessarily precise so much
as direct and determined drawing, which can only be achieved
with concentrated observation. A detail of the painting is
shown opposite.*

I rarely make preparatory drawings for still life or flower paintings. The direct approach is by far the best, and I even find it easier, should the need arise, to realign the initial brush drawing as I go along. It may be that the container, the jar or jug, is too high on the paper to allow for a proper 'breathing' space above the flowers. A soft scrub to remove the first attempt and, once the paper has recovered, a new assessment can be made. Paradoxically, the simpler the subject, the greater the care that should be taken – for every part must count, whether it is clearly defined or only suggested.

It helps if the eye can be caught initially by one dominant feature – in *Small Glass of Roses and Violas* it is the centre rose. To avoid the great danger of passive boredom and too simple symmetry, a small viola has been dropped on the table-top in the foreground to arrest the eye and give an illusion of depth. The glass of flowers sits behind the viola. Breaking up the spaces around the object with subtly changing tones of neutral washes that follow the natural geometrics of the table and shadow shape prevents any area from becoming flat and uninteresting.

Compare any of the illustrations of small paintings of a single subject – a glass or jug or basket of flowers – and see how this approach varies while the effect is constant. In the act of looking, the eye is quickly bored. It needs a constant stream of information to engage and interest it. This is most important for even the smallest, simplest painting. At a more subtle level the tuning of the eye is sharpened by constantly looking at fine work and absorbing the vision of better painters.

'An artist isn't really an artist until he owns a certain number of books,' John Ward, the Royal Academician, once said. He wasn't specific, but I knew what he meant. Ideally you need a continually expanding reference library of favourite artists' work to dip into and learn from every day.

By seeking out flower paintings in oils, small insights of arrangement or composition

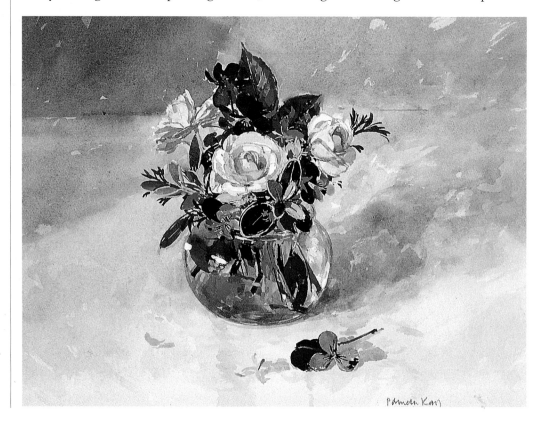

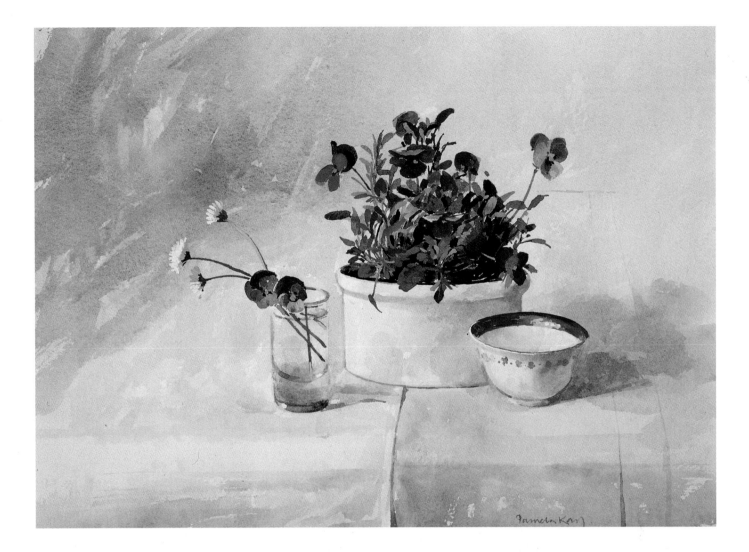

Opposite
SMALL GLASS OF ROSES AND VIOLAS
Gouache, 9x12in (23x30.5cm)

Above
DISH OF VIOLAS AND GLASS OF DAISIES
Gouache, 9x13in (24x33cm)

This is an example of the simplest form of flower painting. A small globular jar holding a modest posy of flowers. It is painted directly with the brush on to white Waterford Not 90lb paper. All the colours were painted very thinly – just as you would a straightforward watercolour. The paper must be stretched.

Only where the leaves have become very dark green and paler definition is needed along the veins or around the edges, has opaque gouache been used. The stalks of the flowers in the jar and the bright highlights are also opaque.

It is ideal if the palest pinks in the rose can be just washes or transparent colour. However, if these pale lights have been lost and become too dark during the work, they are easily recoverable by painting the right shape in the correct tone in opaque colour.

Taking the isolated single bowl or glass of flowers a stage further, this small painting expands very slightly into the realms of still life – they are good companions.

A few of the violas from the main group, placed with some daisies in a glass, provide a repeating echo of the dominant object. The colour of the white daisies, innocuous and complementing the violet, is itself echoed in the very small bowl with the gold rim on the other side of the composition.

The happy, yet subtle, geometry of the cloth provides a useful vertical and a change of colour and plane. Quite understated, it needs only the very simplest of ingredients to make a pleasing composition.

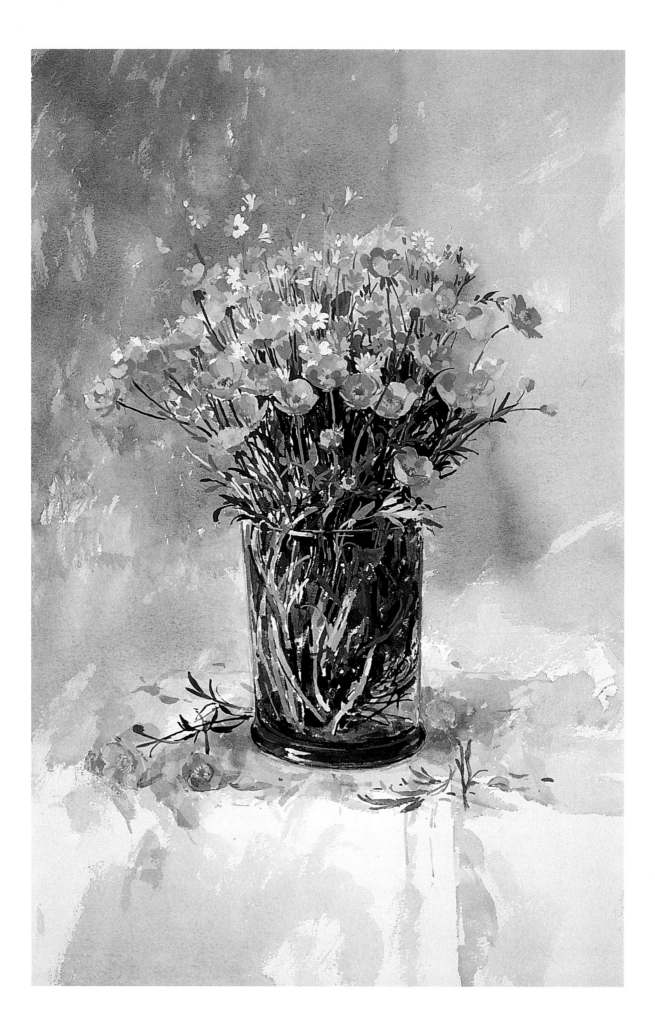

can be gleaned that are useful when working in any medium. Studying work of the past has always been accepted as a very important part of an artist's education. Learning from the past is the best way of enriching the present. Ignoring all that has gone before is not only arrogant but supremely sterile.

Building from the humble jar of flowers towards something more complex is best done in gentle stages. Adding a small bowl or another glass of flowers and grouping them, as in *Dish of Violas and Glass of Daisies* (page 103) is still to work on the same scale with the same intensity. Lessons learned from still-life arrangements carry over and can be incorporated. There is the beautiful sight of counterchanges of tone in the small bowl. Its light rim is against the shadow side of the dish holding the violas. The light on the inside of the same bowl sits against the shadow cast by the dish. The play of lights and darks, warm and cool washes, makes an insignificant event interesting. The quality of transparent glass must be seen to complement the porcelain – a calm surface compared with the busy froth of dark green leaves above.

An analysis of this kind tends to distort the painting, placing a fierce beam of enquiring light on something very unassuming. It is really the illustration of a general principle that is important here. Combining a group of objects with flowers that are the main theme has problems that will be encountered in still life. It all runs together.

Some of the most pressing problems in painting flowers are those of speed and stamina: the flowers' speed of disintegration and the artist's stamina needed to paint as quickly and as accurately as possible. The larger the mass of flowers, the quicker you must work. I find the best thing to do is to paint the major flower-heads in completely where they occur in the composition (as for example in *Table of Summer Flowers*, page 94). Then, hoping that they are in the right place, I lay in a faint framework of key lines in pale ultramarine blue all over the arrangement, and hit it hard with full colour, forcefully, yet with precision. A wash of approximate tone and colour around each major bloom helps to assess tones more easily, but it is a ferocious juggling act, as they have you at their mercy.

A cunning way to play for time is to include plants in pots or dishes that still have their roots well tucked into the earth. It is possible to leave these until last, but even so a dish of violas can grow leggy in the studio at a much faster rate than they do in the garden. A compact mass that began as a neat patch of rich colour can have gone haywire three or four days later. Even so, this can add nicely to a loose abandoned feeling in a dark corner of a painting, so I never mind. The important thing is to be aware that it might happen: then it does not come as a nasty surprise, but something to be taken advantage of.

The group should never be disturbed. Pull out a dead flower to replace it with a new bloom and the whole lot will collapse. Even moving a glass very slightly or attempting to refill it with new flowers is a mistake. The group has been put together at one specific moment. It decays together at much the same rate. Change one element and the whole balance is thrown out. It will be totally different; even the air around it will have changed. It doesn't work. Accept things as they are and grasp the best as it comes. Paint the changes as you come to them if they enhance the painting.

Generally speaking, it is helpful sometimes to work loosely and with attack, estimating roughly the positions of colour areas, and working the tones to full strength, gradually defining and correcting with more opaque pigments.

Gouache, loosely and richly used, can conquer the fear of white open spaces in paintings. Unless the work is intended to be a study, when the paper can be left white, there is a fair amount of angst about what to do with the background. Unless you are intending

Opposite
GLASS OF BUTTERCUPS AND
'WEDDING CAKE'
Gouache, 18x12in
(46x30.5cm)

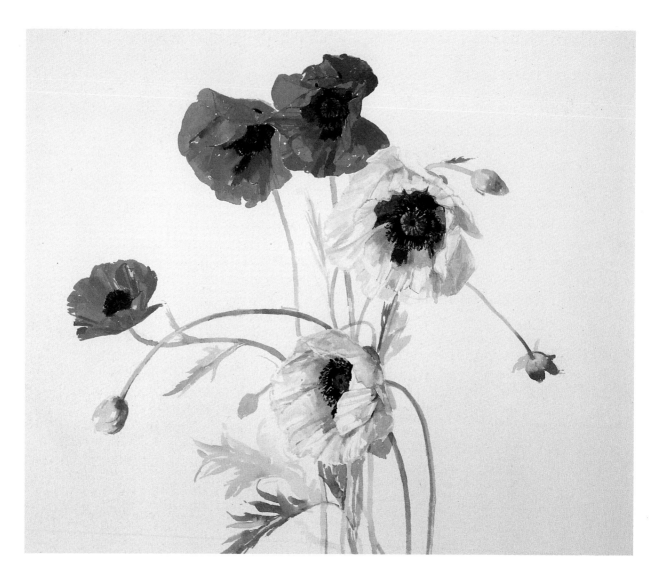

STUDY OF ORIENTAL POPPIES
*Gouache, 18x21¹/₂in
(46x54.5cm)*

to study a flower in an almost botanical way, it is important to think carefully about the setting and background of the subject.

A distinction must be made here between botanical illustrations and flower painting. In the past, as today, botanical drawings were made with watercolours and kept carefully in portfolios, so many have survived. (Usually they had been specifically commissioned by patrons, so there was a sound motivation to protect and keep them.) Their added scientific value ensure that they weren't thrown out with the old saucepans when their owners moved house or tired of their decorations. They were treasured for their beauty as well as for their scientific information.

Botanical illustration is the scientific portrayal of a plant showing its collective and specific characteristics, making it immediately identifiable to any other enquiring mind. It is like a map. The French painter Redouté raised this science to an unsurpassed art form of great delicacy and beauty, compiling portfolios of rose studies for the Empress Josephine. Flower painting, on the other hand, is a portrait of the bloom in which feelings towards the subject are all important. It is not a dispassionate affair, and it is usually painted in a setting.

I have always made a practice of painting broken washes very freely behind the main

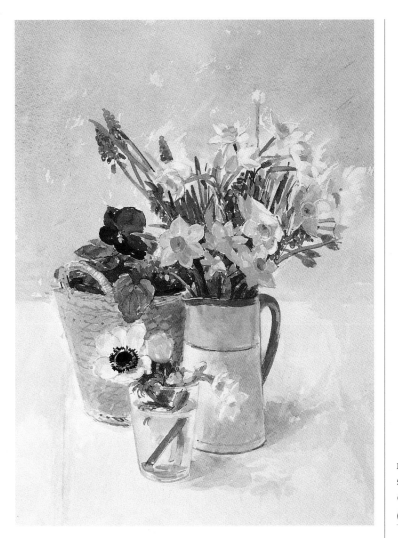

MONET JUG AND
SPRING FLOWERS
*Gouache, 19x12in
(48.5x30.5cm)*

subject of any studio work. Flat washes are as thrilling to me as paying bills, and I can never see why 'pure' watercolourists are beaten so severely with this stricture.

There are usually three to four darkenings of any background with washes to get to the correct tone. As the work on the main subject progresses, it is important to keep the tones of everything balanced simultaneously. Each successive background wash is slightly broken in character and only laid on over bone-dry paper, giving a final background which is of faintly flickering, almost subliminal interest – but alive.

But it is the ephemeral nature of flowers that is so fascinating, and I have a secret satisfaction in throwing out a glass of dead pansies knowing that they are gone; at last my painting of them no longer looks odious by comparison!

The extraordinarily transient quality of flowers and the changing nature of gardens demands an approach quite different from still life. Painting a garden is really a flower painting stretched to its largest dimension. All the problems of change and decay, light and weather are present, but on a larger scale. Garden painting is the ultimate and greatest of all organizational feats for a painter, but a logical progression from the study of still life and flowers.

'Artists shouldn't have gardens,' John Ward hissed through gritted teeth as he put down his brushes and reluctantly dragged himself away from his work – to mow the lawn.

Chapter Five

GARDENS

ainting flowers, although a gentle enough occupation, is vastly more interesting if you grow your own. It is obvious, really, but it took me an extraordinarily long time to realise this, not trusting my horticultural talents to do anything more than raise a smile, let alone a sweet pea.

I had always bought my flowers – garden pinks, chrysanthemums, lilies – from my local florist, leaving my own pathetic clematis and irises to the legions of snails that regard my garden as their exclusive dining club.

I found that I couldn't organize plants and their habits in the same way that I could a flower or still-life painting, and the experience was strange to me. I was eternally impatient with the time it took to get plants in and growing; then they bloomed once and disappeared, which I always thought ungrateful of them.

MECANOPSIS AT
GOODNESTONE PARK
Gouache, 13x20in
(33x51cm)

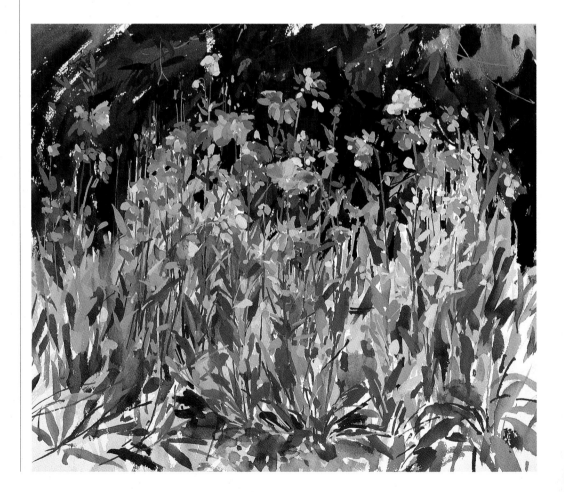

Opposite
FLOWERPOTS OF PANSIES
Gouache, 20x13in
(51x33cm)

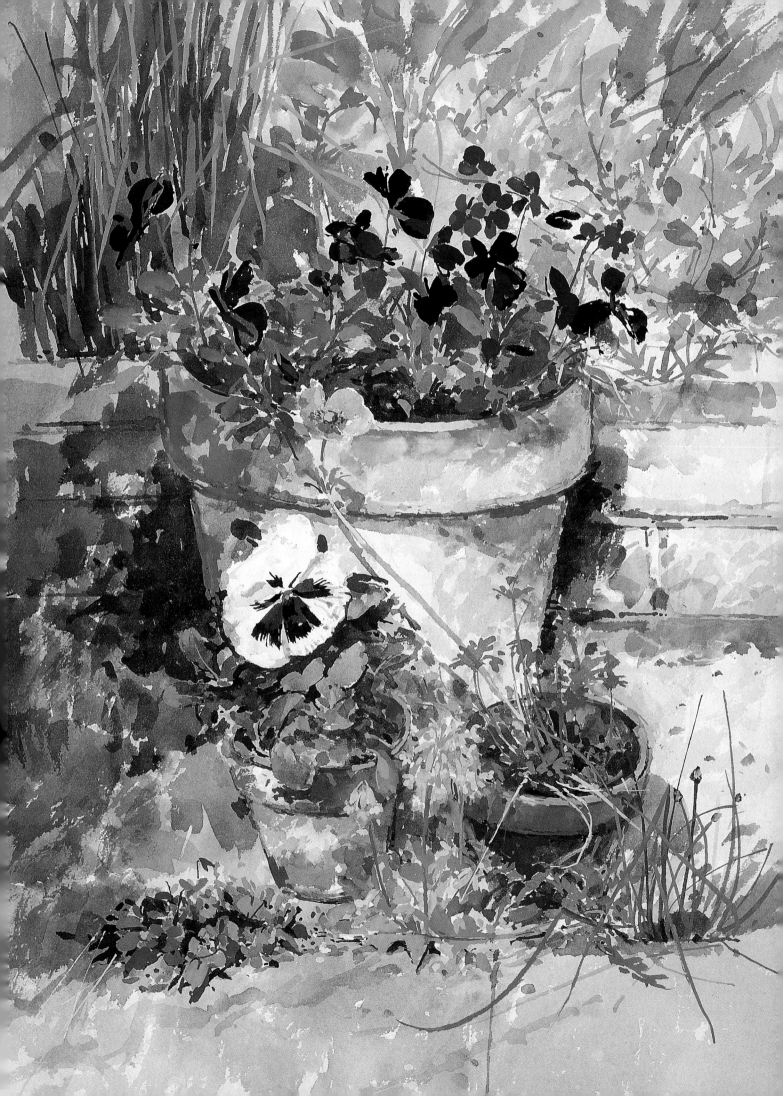

Picking the successful survivors and painting them made flower painting a pleasure. Suddenly the garden itself began to look interesting, too. We are a nation of garden-lovers and every front garden is a self-portrait of its owner – a terrifying thought.

Although painting gardens is not easy, it seemed to me to be a natural progression from painting still life and flowers. The flowers in a garden, however, are on a grander scale and I discovered that it is possible to do a little manipulating and arranging, much as one would in setting up a group of objects for a still life. Of course, moving things around is on a more limited scale. Not having an army of gardeners to wheel orange trees from the orangery in late spring, as they did at Versailles, cramps the style a little, but pots of lilies can be shunted at will to good effect.

Most plants can be grown in pots, and I have stringy sunflowers and leggy pinks that survive well as long as I remember to water them regularly. I move them, rather like stage scenery, to exactly the right place for the needs of the painting, and a splash of yellow can be had on demand, simply by the subtle shuffling of a sunflower.

But I am severely disadvantaged by my ignorance of gardening. Mine is really quite a small town garden, with beds around a paved area. There are apple trees, lilac and buddleia; a vine or two that give magnificent burnt yellows and oranges in the autumn, and some blowzy roses. It is neither well kept nor skilfully tended. I have perennial weeds that flourish nowhere else in the Kingdom and have already been through my brother's horse.

From May to the end of July, the garden runs riot, throwing up masses of old-fashioned roses, poppies, marigolds, pansies and hollyhocks. It is a wonderful sight and overwhelming. Sadly, as I can't bring myself to prune it all back (because it could well 'come in handy later' for a painting), August is a blighted month. It all becomes exhausted by its fecundity, and seeds, withers, and gives up. It is overgrown and all green; a pretty desperate situation. I poke about looking for the odd Michaelmas daisy to add to a still life of plums, but it is really quite arbitrary and chancy. The rainfall will determine what will grow and the sunlight how well.

Each year is marvellously different – from the pale arid droughts of the mid 1970s to the soggy greenery of 1994. Anyone who manages a garden will know what I mean and will have experienced the constant uncertainty of the English summer.

Gardens are really only interesting to paint if they are full of colour, light and shade, and texture. Contrasts, in short, that are the necessary basics for most successful paintings. As I write, mine is a wilderness of self-sown hollyhocks, gently uprooting flagstones with their dogged tenacity to grow between cracks, and tightly packed sweet peas and marigolds – again self-sown. Herein lies the secret of good artistic gardening: 'self-sown'. Do not interfere with what's going on naturally.

There is nothing more tedious for a painter than the tyranny of a bowling-green standard lawn surrounded by regiments of well-ordered and evenly-spaced flowers. It all makes for indifferent painting, and takes up too much valuable painting time to maintain.

Gardening should be like housework – gently neglected. Let the stuff run riot and you will have massed colour and texture, and a much better painting. The cottage garden at Sissinghurst and the poppies at Giverny are a fine example of swathes of colour – which are marvellous to paint.

POPPIES, GIVERNY (study)
Watercolour, 8x10in
(20.5x25.5cm)

Initially I began by painting garden flowers *in situ* rather than in a glass in the studio. A strand of tangled clematis in front of a faded grey wooden fence would have been impossible to take indoors, but looked lovely where it was. Bit by bit I moved from just flowers to include parts of the garden as well.

The difference between launching into a large painting of trees, roses and massed borders, and contemplating a jam jar of buttercups, is one of an intimidating complexity and scale. It has to be worked up to gradually. But then that has been the constant refrain throughout this book, revealing, no doubt, a careful approach and a certain cautious reserve.

However experienced a painter is, it doesn't alter the fact that painting a full-blown summer garden has much the same complexity as confronting and capturing the façade of St Mark's in Venice. Painting and drawing are almost entirely about observation. It is what you notice about life that is interesting. This is a talent that can be developed, and a keen awareness of what is happening about you is best absorbed simply by being still. This is why artists are so good at it – sitting and watching and recording life as it happens around them.

Painting in my own garden, rather than in a public place, gives me more time and freedom to work in longer stretches at the right time of day for the picture in hand. Each year is better for a different flower – poppies will flourish everywhere one year, foxgloves or lilies the next. It is unpredictable and demanding.

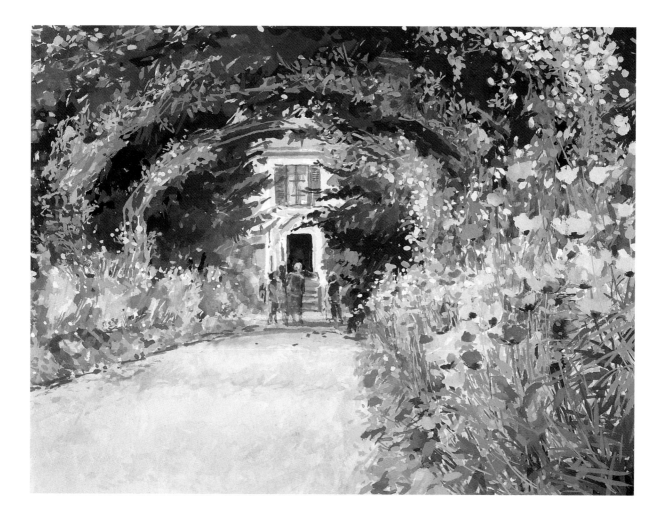

THE GRANDE ALLÉE, GIVERNY
Gouache, 18x22in (46x56cm)

*It is interesting to compare here a watercolour sketch done on the
spot in Monet's garden with a gouache of the same subject painted
later in the studio.*

*I spent a very short afternoon at Giverny in May determined
not to leave empty-handed. I made a few pencil sketches that were
rapid, the watercolour sketches were mere notations, but I spent a
longer time on a watercolour sketch of the Grande Allée.*

*It was too early in the year for the nasturtiums to have carpeted
the gravel along the Grande Allée, but the beds were full of poppies
and the roses were just beginning their summer flowering. I had
about an hour to work and found a quiet area away from the
crowds that teemed incessantly all around.*

*I can remember fighting the watercolour medium, unable to
achieve, even remotely, the intensity of colour before me. It was a
frustrating experience, short of time, short of colour, and short of
the peace and quiet that only Monet and the fortunate gardeners
would enjoy.*

113

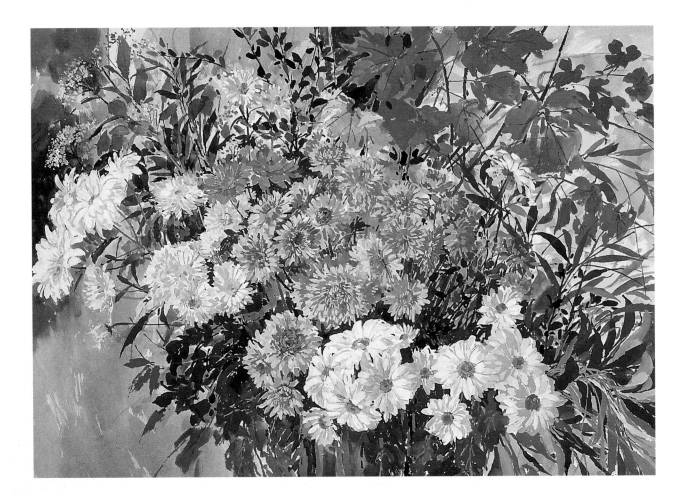

CHRYSANTHEMUMS
*Gouache, 18x22in
(46x56cm)*

The greatest distance my dinner-plate palette of gouache paints usually travels is from the studio to the garden. The easel, and a large fishing umbrella, or even an arrangement of old bedsheets pinned to a washing line to keep the sun off the paper, complete the bizarre setting for a garden painting on a large scale – and 18x22in (45x56cm) is my idea of a large scale.

I try to use all the day if I can. The light moves round and the part I am painting may only be right for four hours at a time. To get the most out of the light, non-essential time is spent drawing-in the main masses and positioning them all correctly on the paper. Colour washes sit behind the large areas of texture, dark and rich in those areas that need them, with paler tones that preserve the luminosity of the paper underneath in the large light areas, such as stone paving in the foreground.

Small details of flowers and leaves that may be lighter in tone than the coloured wash ground can be ignored in the early stages – they are drawn-in later in opaque pigment on top of the dark underpainting. The way of working up a garden painting is a perfect combination of an oil and watercolour approach: large areas of rich background colour to paint over in detail later, and pale reserved washes that keep their transparency and luminosity, then are rarely touched.

Each painting is generally prepared along these lines, but each is different. A mass of poppies may need underpainting washes of juicy yellow-greens, sharp viridians and smoky blues – all very pale and the same tone – as a base to help describe the extraordinary variety of colour that will be needed to define the foliage later. The flower-heads of

the poppies themselves can either be left as untouched paper and painted in transparently, or painted in with opaque pigment last of all. There is so much room to manoeuvre.

The painting moves on in a quiet yet concentrated way, accumulating layers of observed information. A scaffolding of architectural features, such as a post or wall, which underpin textural looseness, must be firmly placed in the abstract structure of the composition. Pots of flowers must be assessed for their correct proportion and position on the paper, and areas of darkest tone and colour indicated. After that it's hell for leather until the sun moves away and all is in deep shadow; and unpaintable.

After the initial drawing-in of the composition, it is better to work only at certain times of the day when the light is right. It is worth having two or more paintings running simultaneously to take advantage of the changing light at different times. Light transforms the scene. A bright sun on a summer's day will bring everything to life, and make a painting sparkle and breathe. Overcast days are worthless. Painting time is only of interest to me in the summer months when the the garden is at its most colourful. The spring can have the odd day of sharp light, autumn a colourful spell, but there is something sad about the withering of plants and the chilly deadness of winter. The season for working is short-lived. Painting has to be fast and furious and determined. It is not easy.

Sharp observation of the seasons, however, is revealing. An oil which I painted in early January showed a striking warm light that cut across some trees; this only happened at noon on very clear bright days, and only that particular year. The following year, after a

JAPANESE ANEMONES
AND DAISIES
*Gouache, 18x22in
(46x56cm)*

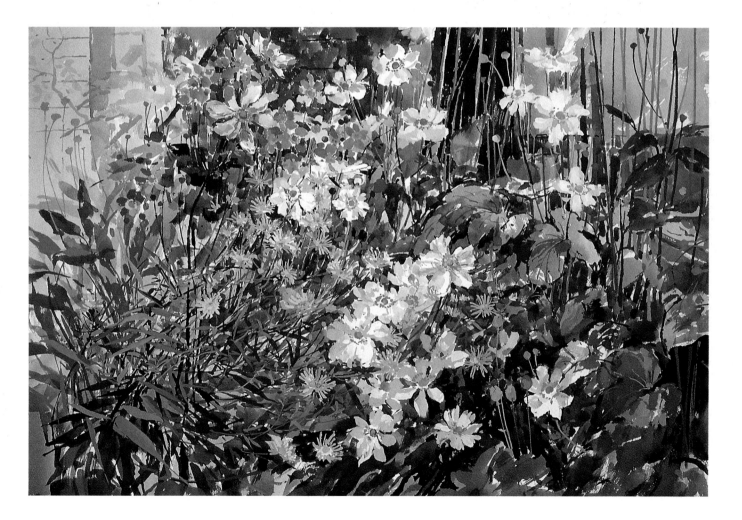

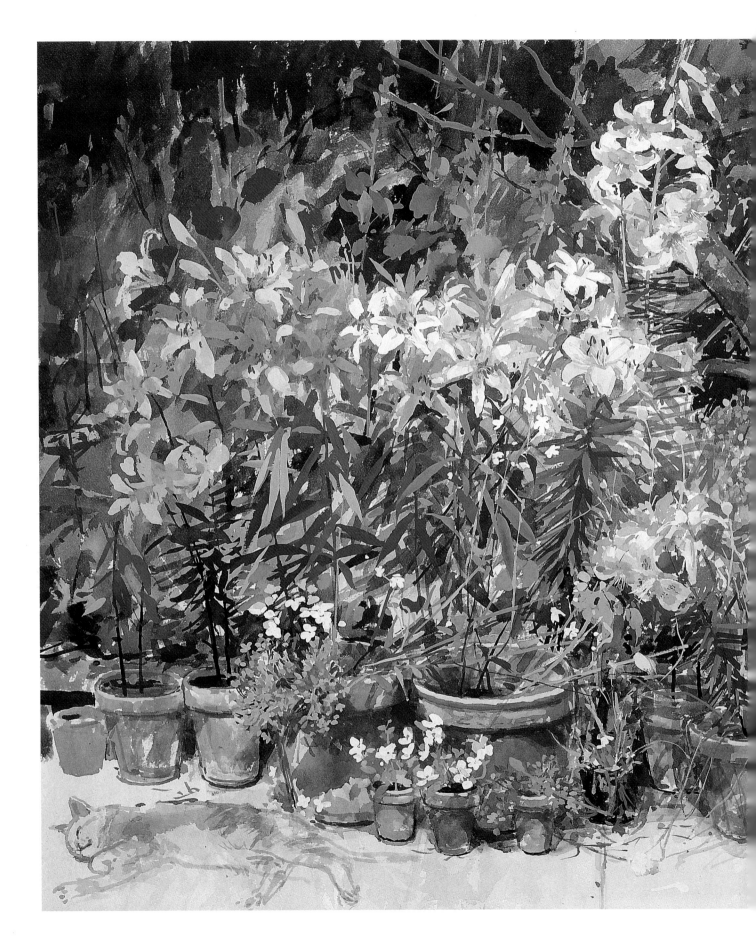

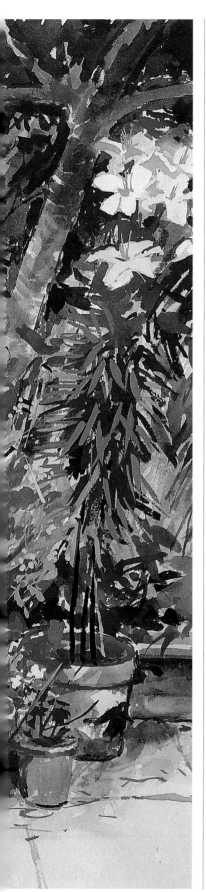

wet summer, a rambling 'Cécile Brunner' rose had grown rapidly, cutting out the light. What light there was had no warmth that January, and everything had changed. It is all so transient, so ephemeral, yet I persist in thinking it will be forever the same. It's really not that straightforward.

Even so, gardens essentially are about colour and texture, and the composition and abstract design on the paper of these areas are still extremely important to a painting and cannot be neglected. To concentrate solely on a brightly bubbling herbaceous border, like the grand pair at Wisley, would make a very spotty painting, composed with great difficulty. It really doesn't work. It is too amorphous and generalized, too regular and regimented. An intimate, close-focused, view of a corner of a garden, overgrown and richly varied in its lights and darks with identifiable flowers, makes for a better picture.

Painting gardens, however, is the supreme juggling act of all time. The painting shouldn't be too blobby – massed cushions of small flowers are difficult to define – yet it shouldn't be too precise and pernickety either. A photographic accuracy, which can be relentlessly boring, gives no atmosphere or softness. Neither should it be all opaque lumpiness of paint – ideally, transparent passages should balance heavier drawing and colour. It's a tightrope that needs to be walked with care.

Over lunch one day, I was discussing with my husband the difficulties of painting the garden in gouache. It was a perfect summer's day and warm enough to eat outside.

'It would look better if I used oils,' I said, 'because you can work on it and work on it – but then it would be interesting to try that technique in gouache, too – thickly.'

'A sort of antipasto,' my husband said helpfully, over the cheese and fruit. He meant, of course, 'impasto' and he was absolutely right.

It is worth remembering that you shouldn't believe all you read – and everything is possible; you just have to try it for yourself and break your own new ground. Mainly, though, it is a matter of trial and error. I found I leant heavily on Monet as a mentor – again he was painting in oils – but the medium doesn't seem to matter at all. It is the eye, and what it sees to paint, that is important. Vuillard is even more interesting to learn from. His garden and interior scenes were so extraordinary in their technique that it is sometimes impossible to tell whether they were painted in distemper (which resembles gouache) or oils.

The most direct advice is simply to paint what you see. It's all there – possibly too much is there, but trust in what the eye is showing you rather than what the mind is insisting upon. When I first started to paint gardens, I had to think long and hard. What is their attraction? What kind of garden? Why and where to paint? What was I instinctively drawn to, and why?

Much of the 'English' conception of garden painting is based upon the work of Helen Allingham, born in 1848, eight years after Claude Monet. She painted Victorian cottage gardens of rustic simplicity and poverty, with doors wreathed in roses and hollyhocks amongst the cabbages. A debased form of this view has pervaded paintings of gardens, and chocolate-box tops, ever since.

It is extraordinary that at precisely the same time as Helen Allingham was diligently recording a vanishing England, Monet was painting his garden at Giverny, with a gutsy

LILIES AND GHOSTLY CAT
Gouache, 18x22in (46x56cm)

bravura and enormity of scale quite the opposite of the English view. With the unfair benefit of the distance of the years, it is all too easy to see both in perspective.

Monet's garden was a reflection of his success, ambition and stature, as were the size and number of his studios. Helen Allingham produced very fine watercolours, in the English tradition of reportage and illustration – a quite different view as well as a different medium. The important thing is to learn from both.

There was a heightened interest in painting gardens at the end of the last century generally. John Singer Sargent, aware of Monet's work, led the English Impressionists, painting 'Carnation, Lily, Lily, Rose' (Tate Gallery), during his summer stays at Broadway in the Cotswolds.

It is the complexity of the subject – not only dealing with the painting, but the garden, too: its planting, the seasons, the weather, the light – all these things make garden painting more challenging than sitting in the studio with a bunch of roses. I have now settled happily to painting in my own garden, but it wasn't that easy in the beginning. I went garden-hunting initially because my own had been suffering from twenty-five years of dedicated neglect. Children and rooting cats had done for it what mountain bikes do for grassy hillsides. I had no flowers, no trees, nothing left at all.

Yet England is littered with fine gardens. We are famous for it and people flock from the Continent to see how it's done. The popularity of Sissinghurst is legendary and any visit there is accompanied by the hushed fluting of the Dutch language from teeming parties of continental visitors. It's tempting to want to paint in ready-made gardens because it's all there and it's beautiful, but it's not so simple.

I would wander round the National Trust gardens, wondering why even they were not quite right for me, or fuming that it was downright impossible to work there. The narrow paths restricted the use of easels, other people could not get past – and, of course, it wasn't allowed anyway.

The gardens of great houses like Blenheim have a severity and an organized planting scheme which is architectural and in scale with the buildings, but not sympathetic to my way of painting. It is too cold and formal for comfort, and if you are a garden painter, it is vital to know why some charm and others do not. It is far more likely that you will find an interesting painting by the potting shed rather than by the parterre.

It took some time for me to reach the conclusion that painting gardens is as personal a matter as painting a still life. It only really worked comfortably in my own garden because I was in charge. Gardens are a reflection of their owners. Having been to Sissinghurst when Vita Sackville-West was still gardening there, it feels now as though, with her passing, it has lost its creative spirit. Then, it was *her* garden: now, though still beautiful, it seems more the lid of the box only, not the contents.

Monet's garden at Giverny has been recently restored so it is easier to accept it for what it is – still his garden in essence but now at one remove. It is all colour, full of uninhibited swathes of pansies, irises, asters, roses and geraniums. It is this judicious and extravagant massing of robust colour that is for the most part missing in the more restrained English gardens.

English country houses pay respects to greenery and shrubs and space their plants, like flower arrangers do, so that each one can be appreciated individually. The 'cram 'em in and pile 'em high' school of thought, at its most extroverted at Giverny, has a restrained branch in the English Parks Department and can be seen in corseted displays of cinerarias and salvias at the Chelsea Flower Show. All rather formal, and on their best behaviour.

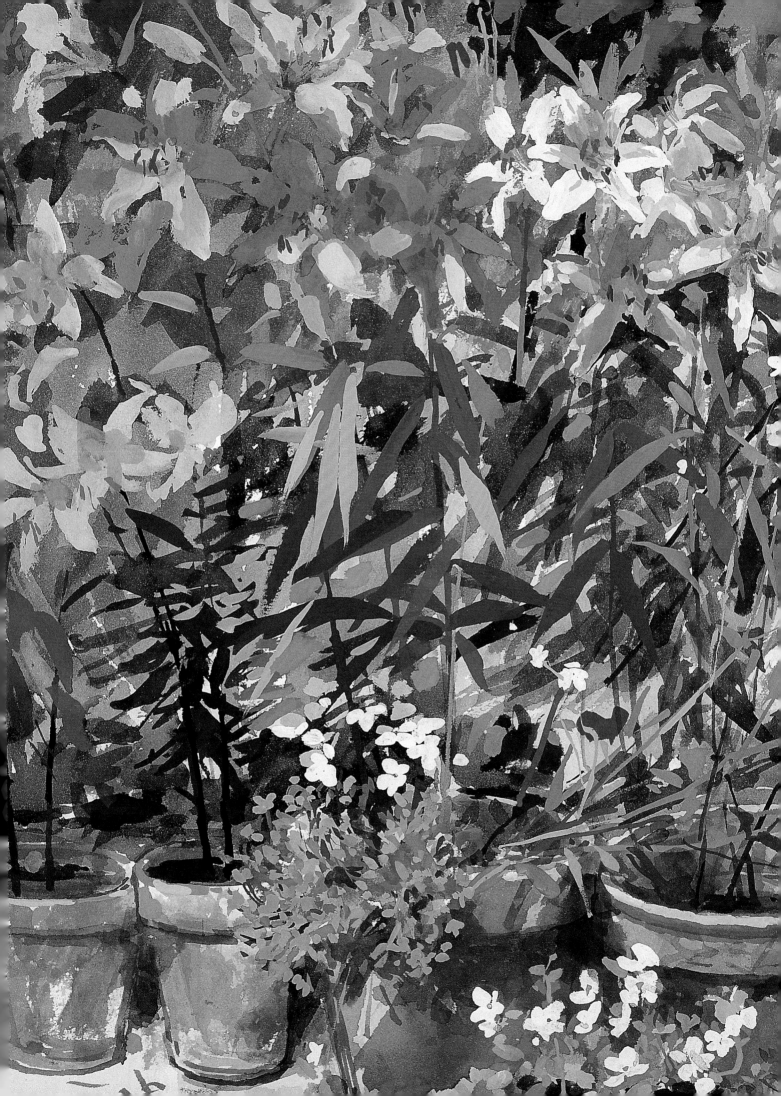

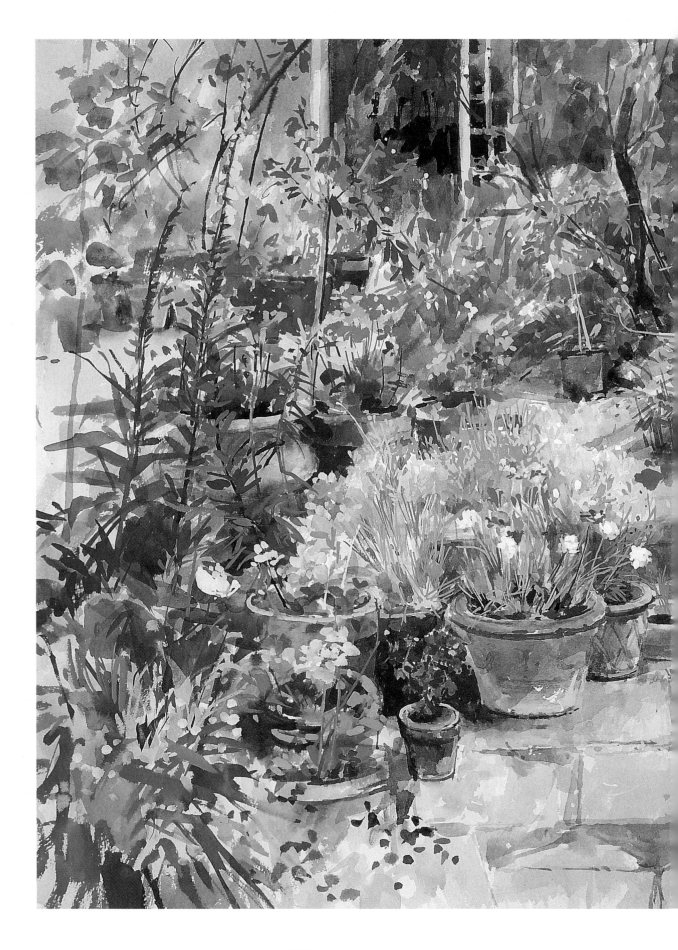

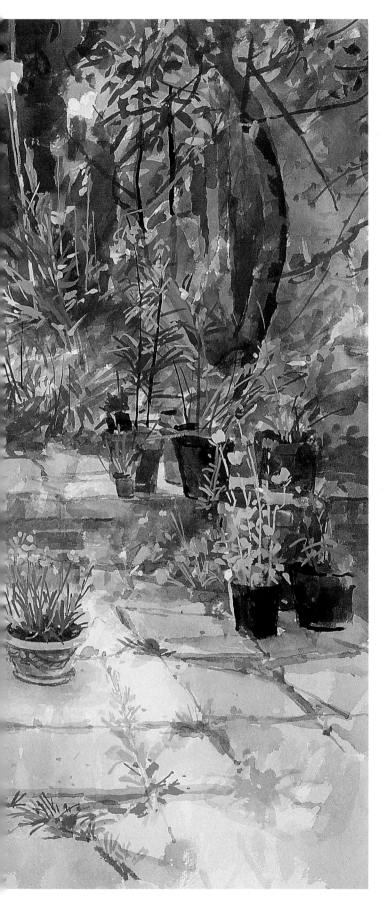

POTS OF CARNATIONS IN THE GARDEN
Gouache, 19¹/₂x23in (49.5x58.5cm)

This is a large and complicated painting. Full of incident and detail, it demands a firm architectural scaffolding underneath the myriad marks, to make sense of all that is happening.

The paving and change of levels give sedentary horizontals – the posts in the background and trees give the verticals. The pots provide a certain solidity. Plants, flowers and foliage can then assume patterns of tone and texture across the surface of the painting.

This would apply whatever the medium being used. The considerations given to the use of gouache would be the same as in any watercolour: keep the lightest tones transparent in the foreground paving. Transparent washes of muted neutral purples, blues and siennas give a rich background to an opaque 'drawing-in' of greens and greys on top. Pinks and oranges of foliage and flowers can also be placed on top of these areas in an opaque pigment.

The coloured grounds mean that there will be no white paper flickering distractingly around flower and foliage. A unity and richness is immediate. Nevertheless, this kind of painting will need working on for a week or so of fine days.

In my experience, only Monet made colour work in the arrangement of flowers in a garden, because his were massed in such large areas which make it worth a grand painting. His was more of a field of flowers rather than a garden, because he was a painter first, rather than a plantsman. The difference is crucial if painting matters more than horticulture, mass of colour more than perfection of bloom, and atmosphere more than strict regimentation.

Although I enjoy visiting other gardens, it is inevitably in my own that I do most work. The practical difficulties of working in others precludes the use of the easels and equipment that would give a large painting true authenticity. Visits to Sissinghurst, Hidcote, Giverny and others mean sketch-book drawings, photographs and colour notations are the only solution. Final paintings have to be worked up later in the studio. In spite of all these prohibitions, it is still a lovely thing to do and I enjoy collecting all the material and making my own studio painting of some sumptuous garden.

It is also the only time in my work that I have to face the thorny problem of photography and its value to the painter. There is more blood shed in local art societies over the question of the use of photography than almost anything else. The plain facts are that you can do what you like. It doesn't matter at all. If you want to sit and copy a photograph, that's fine, but don't call it painting. It is a skill, and if it gives you pleasure in this world of strife, then what could be better? If, on the other hand, you find this a waste of good painting time, as I do, it's important to resolve a sensible attitude towards this problem.

Copying paintings is another matter, and should only be done from the original as a form of study, and never to sell. Copying a painting can give enormous insights into a Master's work. It is only by consciously redrawing or painting from the original that the



eye travels over the same ground with a close approximation of the same intensity that the original artist experienced. Only then will you see the painting properly, in all its detail. It is close, intense observation.

Forming an honoured part of any art school programme in the past, it was expected of fine art students that they would make a copy of a masterpiece as a necessary part of their training. In Monet's day, the Louvre was crammed with students up ladders, surrounded by their paraphernalia, and lasting friendships were cemented in front of a Claude or Poussin.

Photography is here to stay (Queen Victoria declared painting to be dead on being shown one of the first photographs, much to the despair of all her court painters). It's not going to go away. Rather than fight it, artists ever since have used it with varying degrees of success. Photography is powerful magic and as such needs to be treated with a guarded respect. If it completely takes you over, you are lost to the world as a painter. If, on the other hand, you can use it like homoeopathic medicine – working with it rather than against it, in microscopic doses and with careful control – it can be a useful tool.

Photography should only be incorporated into your work when you can do without it. This eccentric observation is paradoxically true. Only when you have the ability to draw and paint from the motif and can retain sufficient information in your head for total recall will it be safe to have a photograph in the studio, and then simply as an *aide-mémoire*. To use it as anything more than that is dangerous.

You can usually tell when too much reliance has been placed on photographs in a painting. There has been no selection, no indecision, no nervousness or quailing at the

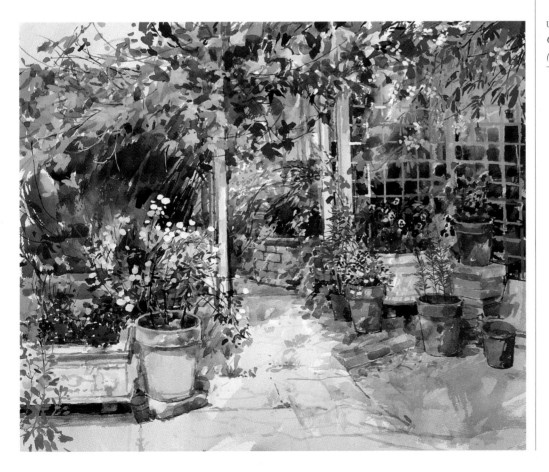

UNDER THE VINE
*Gouache, 18x22in
(46x56cm)*

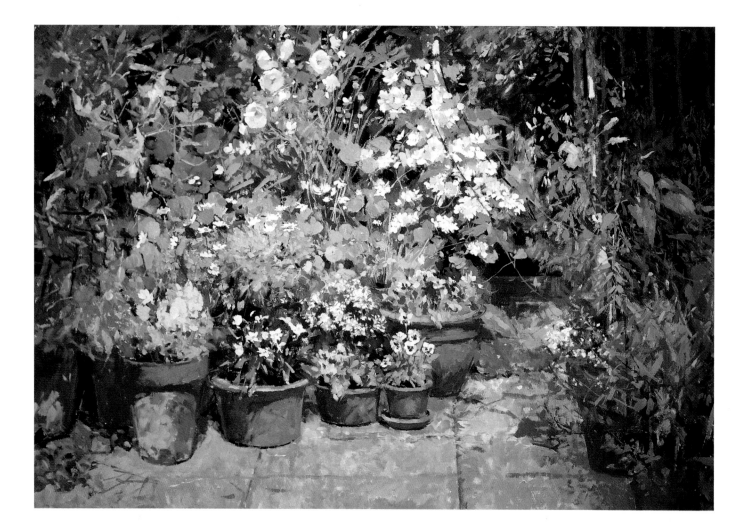

THE GARDEN, FULL SUN, AUGUST
Oil, 24x36in (61x91.5cm)

*This, surprisingly perhaps for a book about gouache, is a painting
in oils. It is included deliberately because, when compared to the
gouache painting* Sidney John's Flower Garden, *it shows how
close to the richness of oil colour gouache can get.*

*Although painted four years after the gouache it is more
disciplined, and shows also the difference between what can be
achieved in one day's work* (Sidney John's Flower Garden) *and
the more considered result that comes from a week spent on the oil
painting.*

SIDNEY JOHN'S FLOWER GARDEN
Gouache, 19x25in (48.5x63.5cm)

My father's garden was more resplendent than the Chelsea Flower Show this particular year. He had planted it all up in this spectacular fashion especially for me to paint.

It took one day of furious concentration, hitting the board of stretched paper with splashes of colour. It was necessary to get it right in tone and colour first time rather than build up gradually.

As there were frequent mistakes and misjudgements working at such an intense speed, it was necessary and possible to work on top with more opaque mixes of gouache than I would normally have used. Speed dictated a looser approach.

This kind of painting is ideally suited to gouache. There is total freedom and every chance to correct and restate parts. It doesn't matter how overpainted passages may become; eventually, with sufficient tenacity and dogged determination, it can all come together in a blaze of colour.

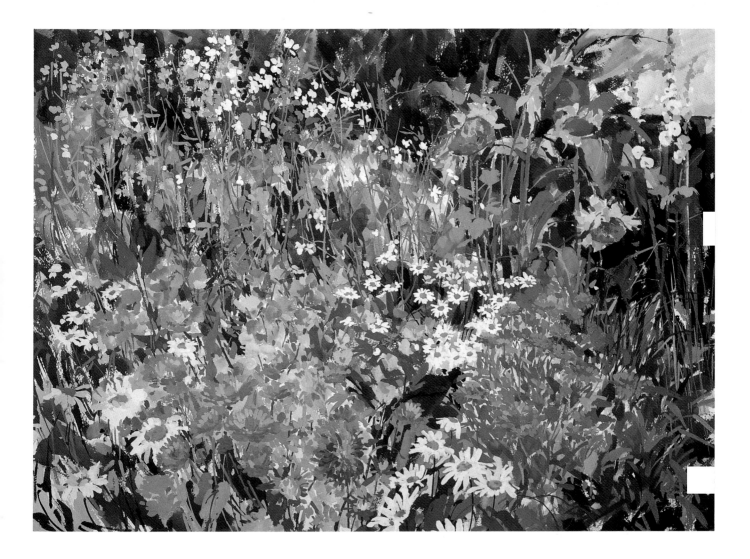

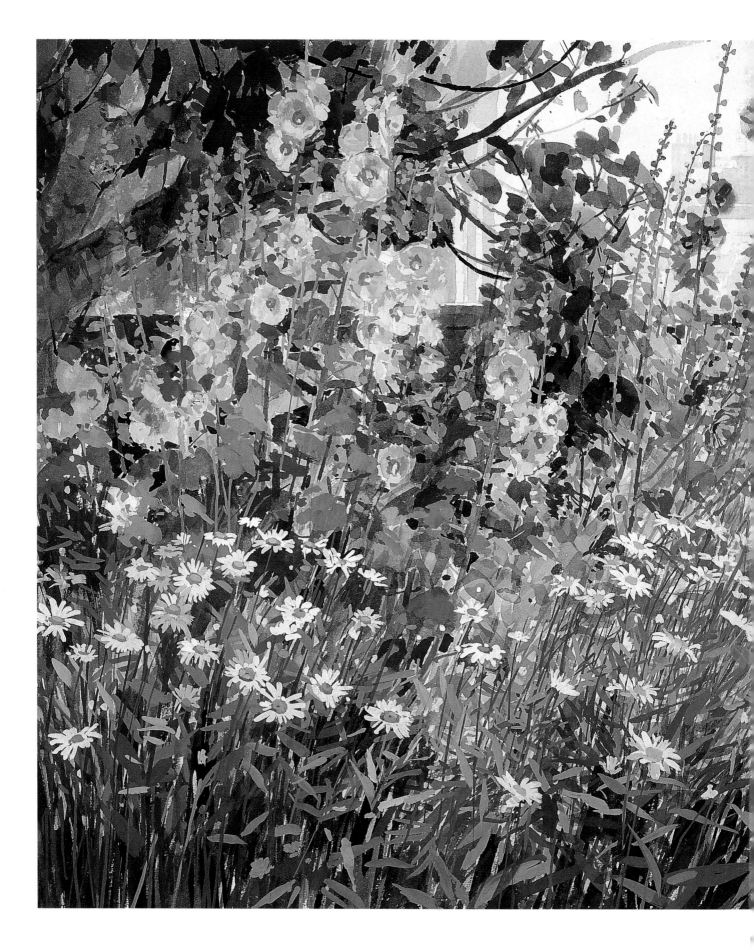

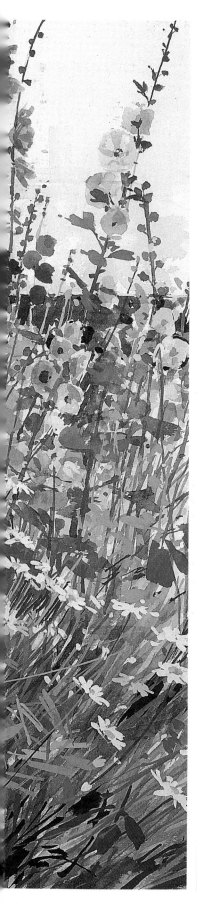

immensity of simply killing the white of the paper or canvas. It's all too easy. There should be qualities of indecision. These help to give life to the work. A too-faithful copy is quite dead, and it is important to remember that photographic film doesn't have a personal selection or your unique sense of colour.

The use of photography reveals itself most crudely when figures appear in paintings in such perfect yet fleeting postures that there is no other way they could have been captured. I have great sympathy for this particular problem; it is so difficult to get models these days.

In Ditchling, Sussex, in the 1920s, there was a flourishing artist community. They liked the south coast and it was an inexpensive place to live with the Bloomsbury Set not far away on the South Downs. The whole village population of Ditchling was employed at some time or another as models for the artists, and saw nothing unusual in it at all. People had so much time to spare in those days.

Nowadays it is much more difficult. Everyone is so busy doing things to save time that they have little, and even less to spare. The pace of life is so fast that there is no time for anything, least of all for sitting still to be put in a painting.

I rarely put figures in paintings of gardens because the gardens I visit have too many people in them already. Gardens should be peaceful places, oases of calm and contemplation, not crowded with other people. I always want gardens to myself, silent and restful. In a painting I can, and in my own garden I am alone.

Over the past ten years, a gradual process of rehabilitation and constant restocking has defied the effects of my horticultural ignorance and given me material to paint. My garden matures and changes. Slowly I realize that I am not in charge at all – it is – and that lilies-of-the-valley may have been planted, but they do not necessarily come up.

So you can see there was a fair amount of sifting and sorting before I worked out a *modus operandi* for painting gardens, or perhaps I was just inordinately fussy – I'm not sure. A subject either speaks to you or it doesn't. If it doesn't, it is better not to stand and shout at it, because it is necessary to go on looking and listening until there is a response. Then there is something to build on.

There is an instinct, an intuitive feeling, that runs like a thread through painting. It guides what you select to paint, what you choose to see, and how you approach the work. Of all the many objects that surround you, it will help to decide what appeals to you personally – what speaks to you in a painting, and what makes you respond. It doesn't have to be put into words or defined; it is a feeling, a sixth sense.

Part of the constant practice of painting is not only the physical doing of it, but also the sharpening, however unconsciously, of this intuitive response. It is like gradually peeling away layers of skin.

This sensitivity to the nature of things, however humble, is at the very core of the pursuit of painting still life, flowers and gardens. The realization that simple, everyday objects have a life and beauty of their own, so often overlooked and unremarked upon, is the best possible reason for bringing them to the attention of others.

HOLLYHOCKS AND DAISIES
Gouache, 18x22in (46x56cm)

INDEX